Free Expression in Acrylics

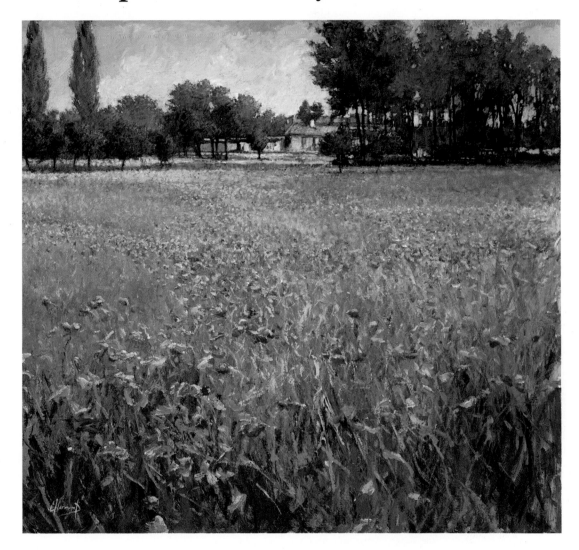

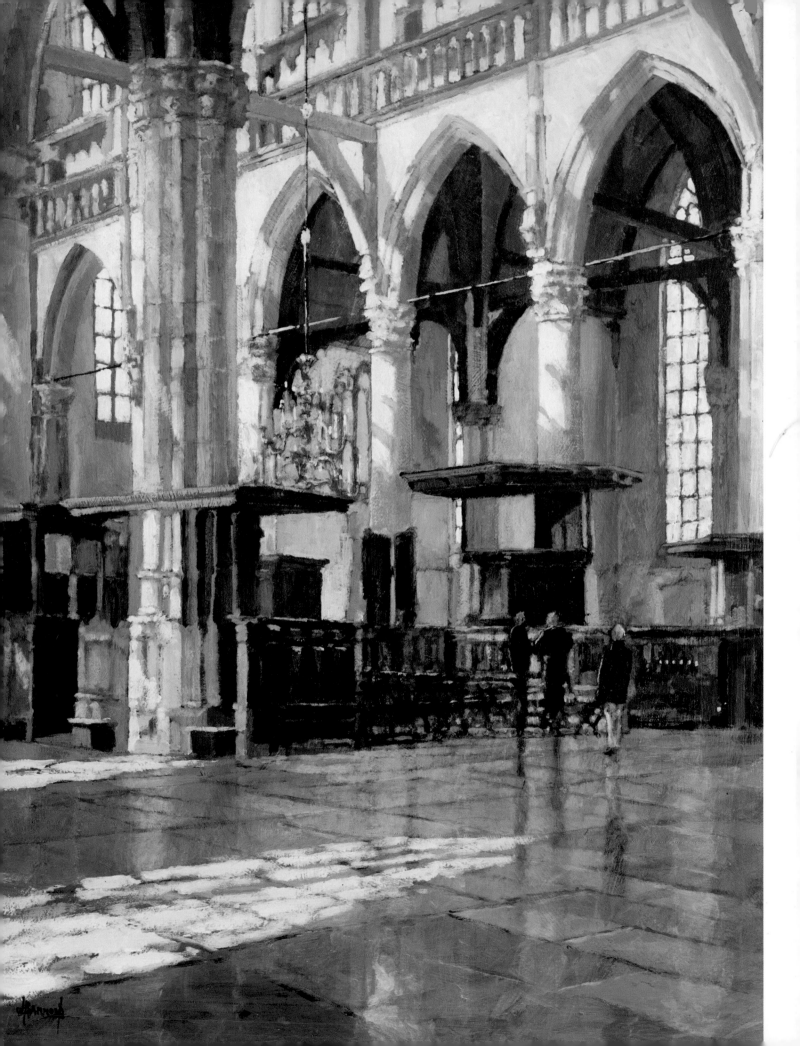

02. SEP
01. OCT
07. NOV 08.

15. NOV 08.
03. 09.

25. MAR 09

24. APR 09

14. MAY 09.
08. AUG 09
26. 09.

2 2 FEB 2010

2 9 MAY 2010

− 1 SEP 2010

− 8 SEP 2011

2 9 SEP 2011

1 3 APR 2012

2 1 JUN 2012
2 9 JUN 2012
2 2 OCT 2012
1 5 DEC 2012

−5 JAN 2013

2 3 FEB 2013

14 May 2013.

1 4 OCT 2014

Please return or renew this
item by the last date shown.
Books may also be
renewed by phone or internet

HA|

East Sussex County Council

eastsussex.gov.uk

East Sussex Library and information Services
eastsussex.gov.uk/libraries

Free Expression in Acrylics

John Hammond
with Robin Capon

BATSFORD

To my dad, for passing on to me his love of the arts and particularly for encouraging me to view and appreciate paintings, with the consequent enjoyment and rewards that this brings. Also to my wife Kate, who is always there for me, even though she knows how unbearable an artist can be when a painting isn't going well.

Acknowledgements

Huge thanks once again to Robin Capon for his hard work and care in bringing together the thoughts and images that make up this book. Chris Chard continues to photograph my work with skill and enthusiasm, for which I am most grateful. Thanks to the galleries that work on my behalf and give me the platform to show my work, and of course to those who buy and enjoy my paintings, thus enabling me to continue. Lastly, a heartfelt thanks to all artists at every level who, by picking up a brush, pen or pencil and sharing their work with others, help every one of us to see and understand things more clearly.

First published in the United Kingdom in 2008 by
Batsford
10 Southcombe Street
London
W14 0RA

An imprint of Anova Books Company Ltd

Copyright © Batsford 2008
Text © Robin Capon 2008
Illustrations © John Hammond 2008

The moral rights of the authors have been asserted

ISBN 978 0 7134 9043 5

A CIP catalogue record for this book is available from the British Library.

16 15 14 13 12 11 10 09 08
10 9 8 7 6 5 4 3 2 1

Reproduction by Rival Colour Ltd, UK
Printed and bound by Craft Print Ltd, Singapore

This book can be ordered direct from the publisher at the website: www.anovabooks.com

Note: All the paintings reproduced in the book are painted in acrylic on prepared MDF (medium-density fibreboard).

(Half-title page)
Glorious
61 x 65 cm (24 x 25½ in)

(Title page)
Clear Light, Oude Kerk
61 x 44 cm (24 x 17½ in)

(Opposite)
Venetian Mooring (detail)
60 x 44 cm (23½ x 17½ in)

Contents

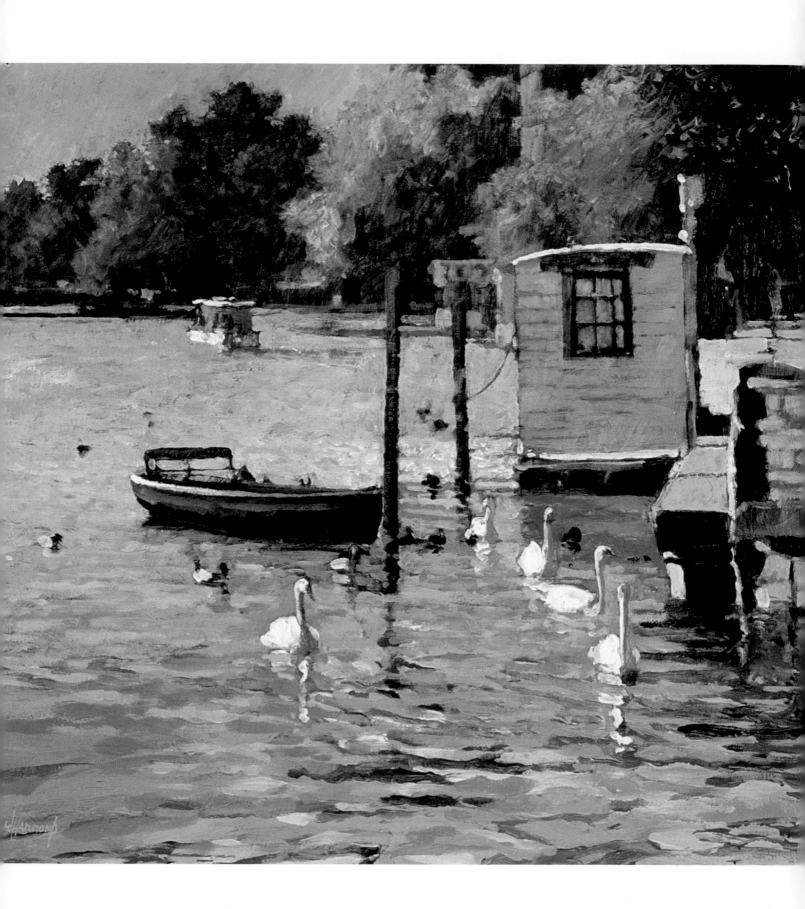

Introduction

Painting is a wonderfully individual and rewarding form of expression. I paint almost every day and for me there are two aspects that are always important and satisfying: the challenge of capturing the magic of light, colour and mood experienced at a certain moment in time; and the thrill in sharing that experience with others. For as long as I can remember I have loved to draw and paint, and while this has been something that I have needed to do for my own enjoyment and fulfilment, equally it has always seemed right to show the results to other people. At school, for example, I was often in trouble for making drawings and passing them round the class.

Thus I think of my paintings primarily as a form of communication. And I like variety: I greatly enjoy travelling and finding different subjects and sensations to interpret in my work. Trying out new ideas can only benefit the development of my work, I think. It is interesting to note that most people I meet have a new painting location to suggest – I only wish I had time to visit them all!

John Hammond in his studio.

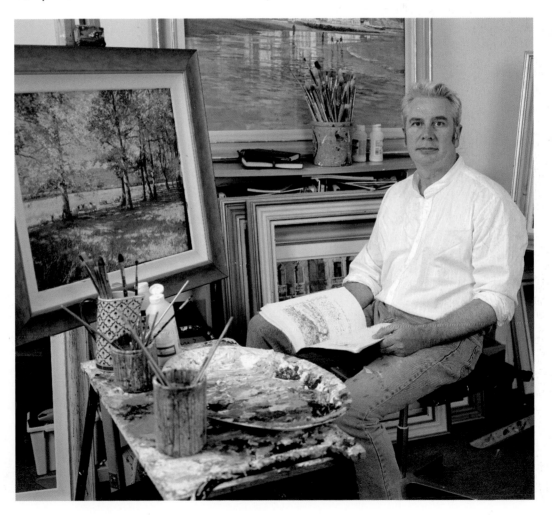

(Opposite)
River Pleasures
35 x 40 cm (13¾ x 15¾ in)
Water is one of my favourite subjects. I particularly like the fact that it allows me to handle paint in a more expressive way.

What is also interesting is that in travelling and painting I get to meet people from all walks of life, and of course everyone has an opinion about art. It is a fact that a good painting will engage the viewer at some level, regardless of his or her knowledge of the subject and genre. However, being married to an art historian, I know very well that sometimes much more can be gained from a painting if we examine its historical and social context.

Whether on site or in the studio, my approach to painting is the same. My aim is to capture the sense of place and therefore I try to evoke what it felt like, for example, to walk across a newly discovered flower meadow or to enjoy the warmth of the sun on my favourite beach. I always try to convey more than simply the appearance of the subject; I want the painting to infer a certain time and mood as well as encourage the viewer to think of the associated sounds and smells – perhaps the cathedral bell ringing or the scent of a lavender field.

These qualities can only come from first-hand experience of the subject and consequently an understanding of it through observation and analysis. Moreover, I still think the best and most immediate way to record that knowledge and information is by making notes, sketching or painting from life. Photographs sometimes provide useful additional information, but I would never rely on photographs alone. To express something with real feeling and individuality, you have to start by getting to know the location or subject through personal observation.

So, my belief is that sound reference material – together of course with a real excitement and inspiration about the subject – must always be the starting point for painting. Then, as I hope is clearly explained and demonstrated in the various sections of this book, in expressing an idea with conviction and impact, one has to consider and balance the various aspects that contribute to a successful painting. Design and composition, colour and form, and painterly qualities all play their part. Also, skill and experience count for much, although whatever our level of ability there is always something to learn.

But perhaps the most important thing is to paint with honesty and integrity – to be true to yourself and focus on the qualities that you feel are the most significant, and to adopt an approach that you are comfortable with. Acrylic is a good medium to use in this respect: it allows you to work in an uninhibited way and so share your particular thoughts and feelings.

Nestling in the Appenines
55 x 70 cm (21½ x 27½ in)
I always have a sketchbook
with me on my travels, just
in case I come across a
wonderful subject such as this.

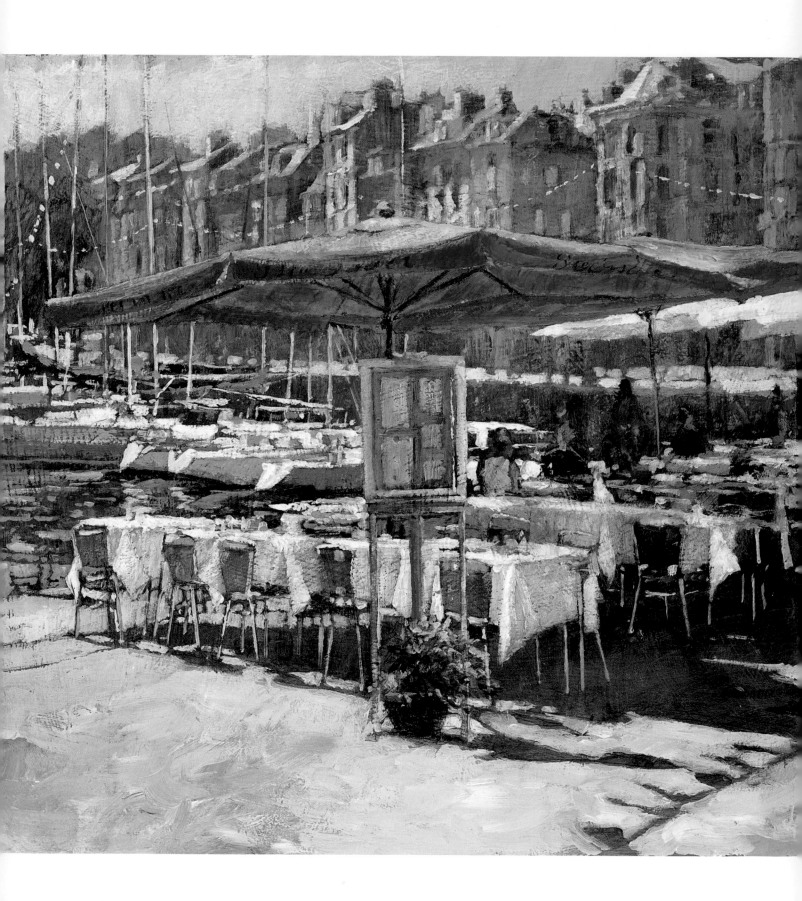

1 Initial Considerations

The motivation and objectives for painting can vary considerably from one artist to the next. Equally, the success of a painting can be judged on different levels. There are some artists, for example, who are heavily influenced by commercial considerations and so concentrate specifically on a style of work and particular subjects that they know will sell well. Alternatively, painting is often the result of a personal response to something, driven by the artist's individual feelings and ideas. In principle my affinities lie with this approach, although I also believe that painting is not something that you do purely for your own pleasure and satisfaction. I see it as a way of communicating my experiences and feelings; of sharing them with other people.

For me, it is vital that paintings have an inherent integrity and honesty, by which I mean that they reflect genuine emotions, thoughts and concepts. A successful painting, I think, is one that fulfils the aims you had in mind when you started it. Light, mood and a particular moment in time are the main qualities that I want to convey in my paintings, and the greatest satisfaction is when a work evokes such a convincing sense of time and place that it creates an equally strong response in other people.

However, when choosing a subject, what matters most is my personal reaction: it is important that the subject moves and inspires me. If it does not appeal to me, I am unlikely to paint it in a way that will capture the interest and imagination of other people. I like variety in subject matter. Introducing a new idea or theme every so often not only increases the scope of my work, which of course is an advantage when it comes to staging exhibitions, but I find it also helps me maintain an excitement and interest in painting as well as keeping the results lively and forward-looking. Inevitably, each different subject presents its own challenges, which again is something that ultimately benefits the development of one's work.

As far as the actual painting process is concerned, while I place much importance on first-hand observation of the subject and making reference drawings, I prefer not to plan the work too thoroughly. When talking about how I work, I often make an analogy between painting and taking a journey – I know the destination, but I have not plotted the precise route. Normally I have a good idea as to what I want to achieve in the end, but I am always willing to consider – and possibly respond – to happy accidents and other events that may develop during the painting process. Having a sort of blueprint for the painting that you must adhere to is very restricting, and it certainly will not encourage free expression!

Inspiration

Most figurative artists agree that the starting point for any painting is inspiration. But what exactly is inspiration? Well, in my view it means being so excited, moved and attracted by a particular scene or subject that you instinctively know that you want to paint it; that it will make a good painting. However, I am not necessarily suggesting that every subject must be charged with high emotion. Indeed, the inspiration could be on a much more subtle level. But the fact is that if you do not feel strongly about a subject, you will not be able to paint it with true sensitivity and conviction. It is not possible to

Red Parasols,
Honfleur
30 x 36 cm
(11¾ x 14 in)

fake an emotional response, and for this reason I never attempt any subject that does not have a strong appeal.

As I have said, for me painting is about sharing ideas and experiences. This need not imply anything highbrow or deeply philosophical, but on the contrary perhaps something quite simple, such as a pool of light glinting on the choppy surface of the sea – the sort of thing that, if you were out walking with friends, you would draw their attention to. In the same way, this is what paintings do: they make a point; they relate an experience. Sometimes there is an extensive narrative, while in other paintings this is less the case. But hopefully in every painting there are qualities that people can respond to and feel enriched by.

Providing you have an open mind and do not confine yourself to a specific type of subject matter, the fascinating thing about inspiration is that it can come from the most unexpected sources. *Tea House with Bicycles, Vondelpark* (below), for instance, was an unusual subject for me, but one that instantly impressed me when I suddenly came across

Tea House with Bicycles, Vondelpark
50 x 41 cm (19¾ x 16 in)
You may find it difficult to believe, but what attracted me to this subject was its complexity. I enjoy a challenge!

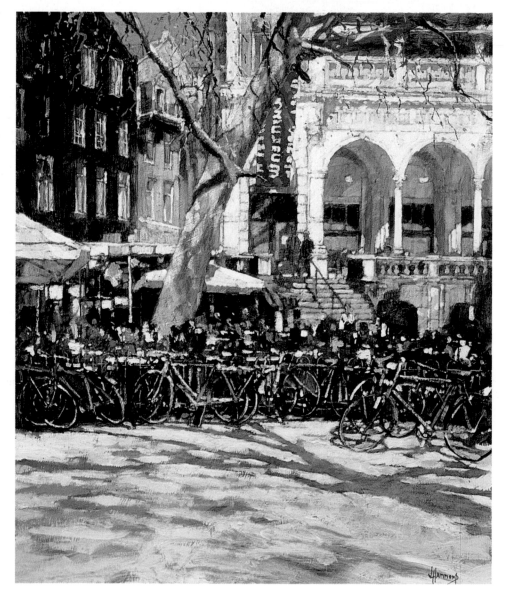

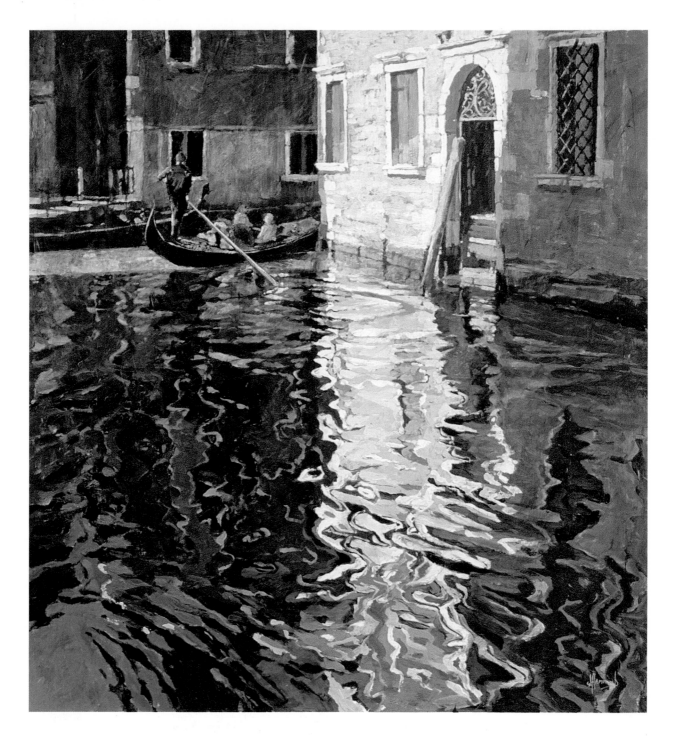

Into the Sun
66 x 61 cm (26 x 24 in)
With its wonderful transient
effect of light, this was a
truly inspirational subject.

it during a trip to Amsterdam. I especially liked the way that the sunlight glinted on all the metal surfaces of the bicycles, and somehow this scene seemed to capture the spirit of Amsterdam and serve as a wonderful reminder of an enjoyable stay there.

Key qualities

In order to convey the impact of a particular place and time, you must first decide on the features and qualities that determine the uniqueness of the experience. What is it that makes the subject so special? Usually the most influential factor is a certain effect of light, so this is the quality to consider first. However, although it is tremendously important, observing and capturing the specific light effect may not be sufficient in itself to fully express the momentary impression of the scene. Also, the painting must convey

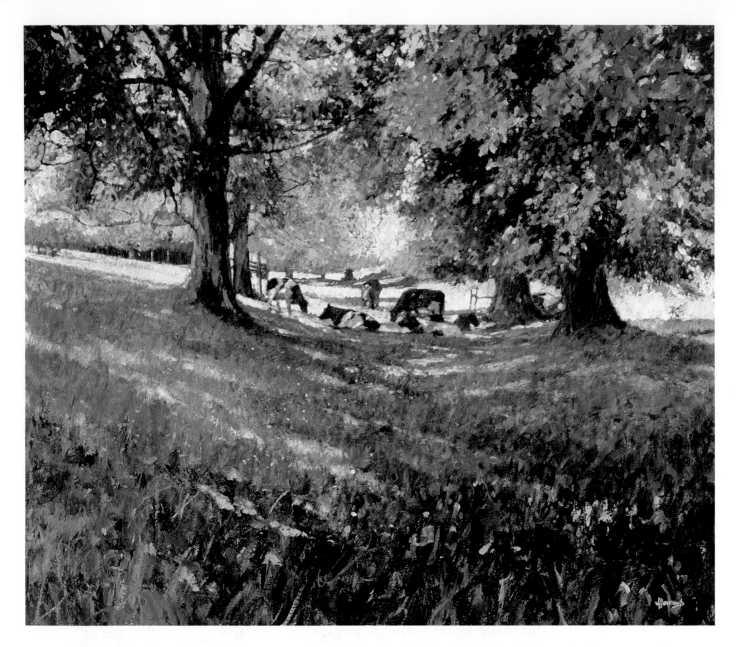

Sweet Shade of Summer
61 x 70 cm (24 x 27½ in)
In this painting I wanted to convey a feeling of tranquillity, which is expressed mainly through the special quality of the dappled light.

something of the wider context, informed by the sights, sounds and other aspects that excited and moved you when you were there.

The best paintings do more than simply represent what is seen: they have an underlying emotive quality; they show a special kind of sensitivity on the part of the artist. It is not enough just to hold up a cardboard viewfinder and reproduce the image that it frames. Rather, it is vital to assess all the elements that contribute to how you feel about a subject and allow these to influence both the content and the painting process. And within the painting, you have to find a method of drawing attention to those aspects that you regard as especially important – perhaps by exaggerating them in some way, or by underplaying or even eliminating other aspects.

It is the influence of light that creates the distinct mood and atmosphere of a scene, and obviously there is an immense challenge in capturing such a transient effect in a painting. Usually, when a subject attracts my attention, it is because of the particular quality of light. But there can be other triggers, for example an exciting flash of colour or the overall impact of a scene unexpectedly encountered, as was the case with *Entering Horse Guards* (opposite). With a subject like this, the most important thing is looking

and remembering, perhaps focusing on a sound or something similar to help you recall the experience. I vividly remember the sound of the horses' hooves clattering along the Mall and, with the notes I made and the photographs I took, I had all the reference material I needed to make a successful painting.

Evaluating ideas

If something truly interests and excites you, then the chances are that it will make a good painting. However, it is always worth spending a few minutes assessing the content of the subject and considering how this will be managed as a painting in terms of composition, colour, technique and similar aspects. I know from my own experience that while there are some subjects that seem to scream at you and demand to be painted, there are others that you have to reluctantly reject for one reason or another. They may be very appealing and challenging ideas, but lack the cohesion necessary to create an effective design. Or they may simply be too busy and complex or, on reflection, not offer quite the creative potential that you had hoped for.

There are no hard-and-fast criteria in this respect, no special method of assessing subjects that is guaranteed to work for every artist. But the more you paint, the more you begin to appreciate those features and qualities that are likely to enhance the potential of

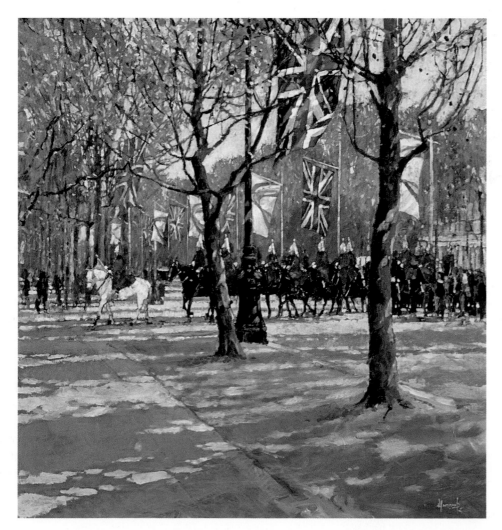

Entering Horse Guards
65 x 61 cm (25½ x 24 in)
With a moving, perhaps unexpected subject such as this, you have to be adaptable with your reference-gathering. Here, I relied on a combination of memory, written notes and photographs.

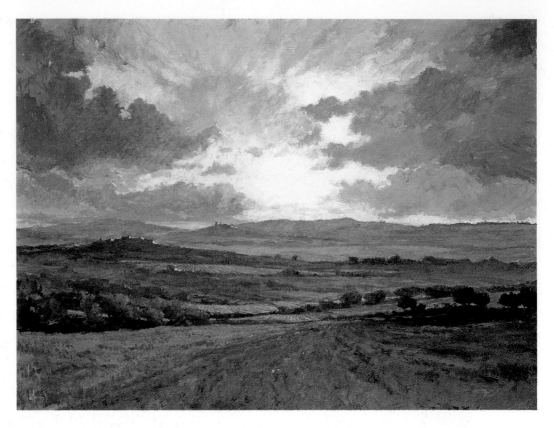

Breaking Light, Tuscan Sky
61 x 80 cm (24 x 31½ in)
This was a subject that I came across early one morning, when out for a walk. I made a quick sketch and also returned on the following two mornings to gather further reference information.

a subject, as well as recognize those that, from experience, you know will lead to immense problems. I like to paint in a way that is true to my initial response to the subject matter and therefore my starting point is always something I have seen and felt inspired by. Working from imagination, or from what I know or think something should look like, is not for me, because it lacks the significance and emotion associated with a specific place and experience.

However, because I start with observation, this does not mean that I am confined to painting in a totally representational way. As I have explained, in evaluating a scene I am also deciding which features are, for me, the most important and which therefore I will emphasize in the painting. This, combined with the painting technique I choose to express my ideas and feelings will, I hope, give the painting its own identity.

Fresh challenges

There is no shortage of subjects, and while most artists specialize to a degree, it is nevertheless important not to place too many restrictions on what you choose to paint. If you concentrate solely on one theme, inevitably there is a danger that familiarity may tempt you into making general assumptions. It is difficult, sometimes, not to base your decisions on previous experience, rather than what is new and different about a subject. The greatest danger of all is in resorting to an established process that appears to guarantee a successful result, but which in fact only leads to repetition and tired, uneventful paintings. Variety is always a good thing.

In fact, there is usually plenty of scope within a favourite type of subject matter to create many different paintings. Moreover, in my experience, the change from one theme to a slightly different one is generally quite a natural process. For example, water, in all its moods and forms, is a theme that I often return to, and even when I focus on a particular aspect of this theme, such as beach scenes, there are always many new ideas to explore. *Surf Seekers* (opposite) illustrates this point. This recent painting shows subtle differences in content, composition and technique from some of my earlier beach scenes

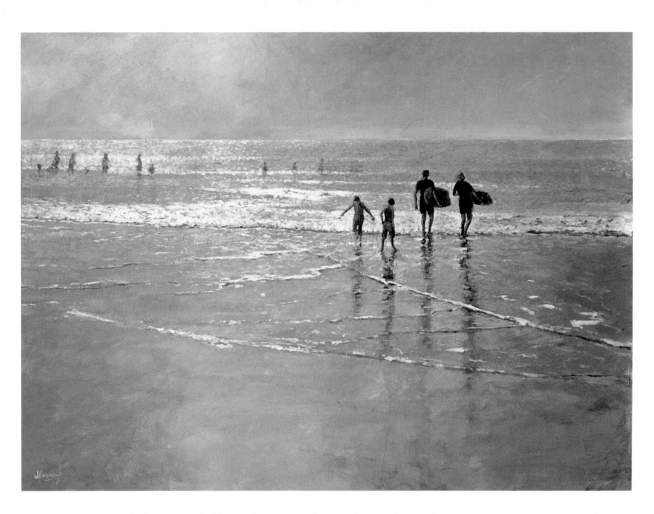

Surf Seekers
61 x 80 cm (24 x 31½ in)
I often paint *contre-jour*
(back-lit) subjects such as
this, in which the
emphasis is on the strong
tonal contrasts.

with boats or children playing on the sand. See also *A Quiet Moment* (page 78) and *Shoreline Figures* (page 80).

A variety of subject matter prevents you taking things for granted and helps in developing your skills as an artist. New subjects inevitably bring with them new problems and thus the need to introduce slightly different working methods. In turn, this broadens your experiences and adds to your ability. But, initially, you have to be prepared to work hard and perhaps struggle with a new subject before you find the best techniques to express it with feeling and impact. When I started to paint English pastoral scenes, for example, having previously spent some time working on European subjects, I had to develop new ways of mark-making and handling colour, especially to represent the distinctive lush green foliage.

A visual language

Art is one of the most fundamental methods of communicating information and ideas. From the earliest civilizations, man has made marks and used drawings to record events and express individual thoughts and feelings. In this sense, the visual language of art is international. Certainly there are cultural differences in visual language, but no matter which race you belong to or which language you speak, paintings and drawings will mean something to you, and often their meaning is instant and forceful. There is undeniable truth in the saying: 'A picture is worth a thousand words'. Could this be why most advertisements, political pamphlets and propaganda, and religious messages rely principally on the visual element rather than the written one?

The history of art embraces such a wealth of subject matter, techniques and styles that no artist can afford to ignore its potential to inform and enrich his or her work. I think

there is tremendous value in studying some of the main movements in art and especially in looking at work by artists whose approach relates to your own. In my view it is not possible to divorce yourself from the general context of art history: essentially, as soon as you pick up a brush and start painting, you are part of that context, so why ignore it? Why not celebrate it instead? What you can learn from other artists can be invaluable. After all, traditionally this was the way that most artists learned their craft. An apprentice working in the studio of an established painter would copy the methods of his master to begin with, though gradually modifying or expanding them and so forming a style of his own.

Another advantage of looking at other artists' work is that it helps you develop keener powers of judgement in relation to composition, use of colour, paint handling and so on. Consequently, this can have benefits when tackling similar aspects in your own paintings. As artists, we all come across the same problems and challenges in creating a painting, and we can learn from studying how others have overcome those obstacles. Additionally, it is worth remembering that while practical skills are vital, they are not sufficient in themselves to create meaningful paintings. The emotional and intellectual aspects of painting are equally important, and certainly a contributory factor in developing these aspects is the study of art history.

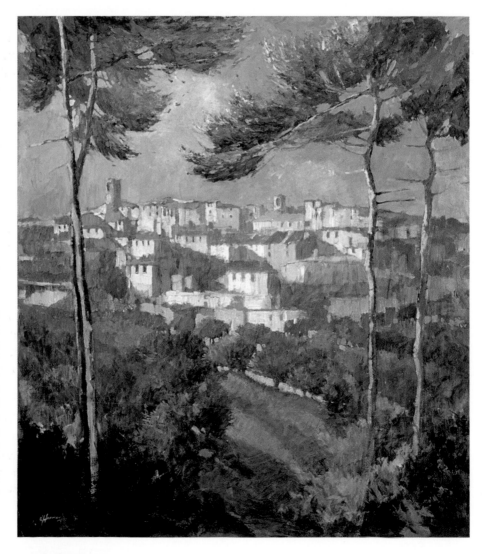

Massa Maritima
70 x 55 cm (27½ x 21½ in)
It is not possible to divorce yourself from the general context of art history and perhaps even to have a specific artist in mind when you come across certain subjects – here it was Cézanne, for example. But always try to paint with your own emphasis and using your own techniques.

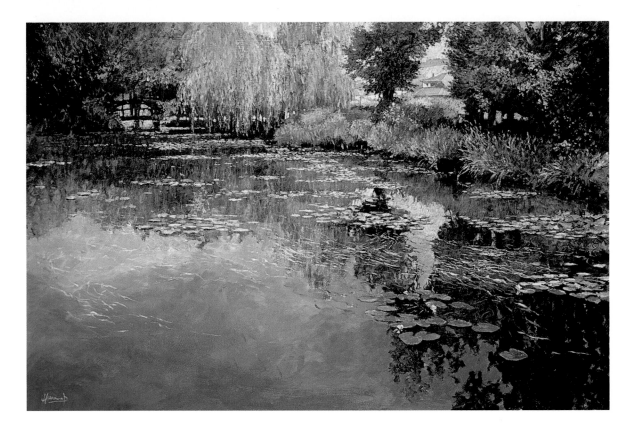

Artists and influences

I enjoy looking at all kinds of paintings, but it is the Impressionist style of work that has always interested me the most. In fact my technique is quite different, particularly in that I use a lot of transparent glazes. However, in terms of the general emphasis and intention, I think my work has close similarities to the principles of Impressionism. I greatly admire the way that Monet, in particular, created wonderful effects of light and mood by using exactly the right colour harmonies and painting techniques. Like Monet, I firmly believe that paintings have the ability to capture a moment in time. But of course this can only be achieved by developing an empathy with the subject matter as well as skills with the painting medium.

In the spring of 2006 I fulfilled a long-held ambition to see Monet's garden at Giverny, and I have since returned a number of times and have made several paintings inspired by my visits – see *Still Waters, Giverny* (above). It was fascinating to be where Monet had been and for me, the garden seemed just as much a wonderful creation as some of his paintings.

I had not considered gardens as a painting subject before, but what especially impressed me at Giverny was how well the garden had been designed, with different features that would give structure and interest in a painting. At first glance there is such an assault on the senses, with all the various colours, shapes and textures, that the overall feeling is one of chaos. But then you begin to notice the verticals and horizontals, such as the reflections in the water and the water lilies themselves. These elements help to unify different scenes which, in turn, will translate into successful painting compositions.

Appropriate techniques

The ability to express an idea successfully will, in part, depend on your skill in selecting and using appropriate techniques. Naturally, acquiring a good understanding and knowledge of different techniques takes time, for as with most aspects of painting, progress relies largely on experience accumulated from practice and experimentation. Moreover, the scope and effectiveness of the techniques will obviously be influenced by

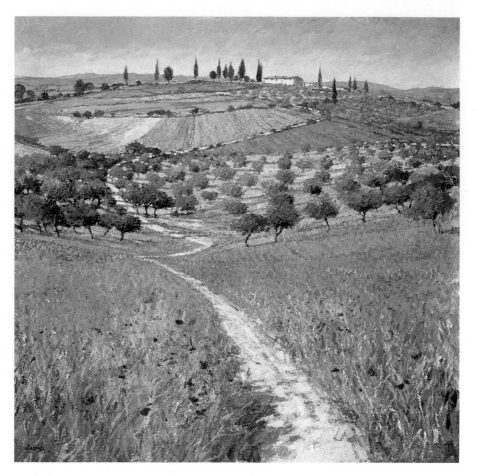

Olives and Poppies, Umbria
80 x 80 cm (31½ x 31½ in)
I tried to replicate the sense of
the dry and dusty landscape
in the way that I applied the
colour in this painting, using
mainly scumbling and dry-
brush techniques.

the choice of painting medium, and therefore it is essential to find a medium that gives
you the confidence to work freely.

For me, acrylic has some important advantages over the other two main painting media.
At the beginning of my career I tried working in both watercolour and oils, but I never felt
really comfortable with either of these. Watercolour was too restricting: it was not possible
to develop qualities such as texture and depth without overworking the medium and
losing the translucency and freshness of the colours. And with oils I was frustrated by the
drying time. Although I was eager to press on with the painting I had to wait until the
surface had dried, and this meant having several paintings on the go at the same time.

With acrylic, however, which dries quickly, I found I could work with layers of colour
without undue interruption – so there was a more natural flow to the painting process.
This suited me perfectly, because once I start a painting, I prefer to work through almost
to the end before switching to something else. I also like the way that I can use very thick
acrylic paint straight from the tube, together with areas built up with translucent glazes.
In fact, this approach is the basis of my technique.

I make the glazes by mixing colours with gloss glazing medium rather than thinning
them with water. Although adding water does help improve the fluidity of the paint, there
is a disadvantage in that it reduces the intensity of the colour. Also, too much water can
affect paint adhesion and cause the colour to go cloudy. The intensity of a glaze colour
will, of course, depend on the amount of gloss medium added to the mix, but be aware
that if you add white, the glaze will become more opaque. Sometimes I apply as many as
forty successive glazes to achieve the depth, vibrancy and interest I require for a certain
passage of the painting.

The other big advantage of acrylic paint is that it is a very straightforward medium to
use. There is no set procedure to follow and, no matter how thickly or thinly you apply

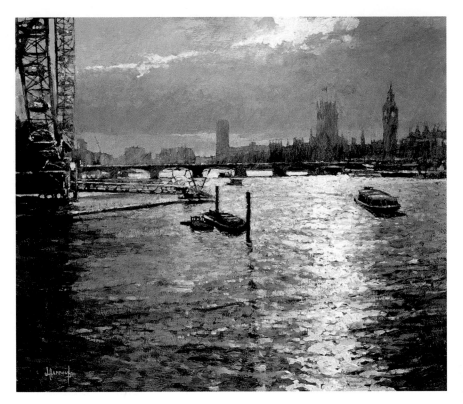

Late Afternoon; Silhouettes
42 x 48 cm (16½ x 19 in)
This is predominantly a tonal
study developed gradually
with a sequence of glazes
and, in some areas, thicker
layers of paint.

the paint, you can be sure that it will dry without unforeseen problems. Also, highlights and light areas can be introduced at any stage of the painting, and wrong colours and mistakes are easily rectified – you simply paint over them. There are different brands and varieties of acrylic paints to choose from. I prefer Liquitex high-viscosity colours, which offer just the right consistency for the way I like to work.

Late Afternoon; Silhouettes (above) demonstrates some of the techniques I normally use. Starting with a dark-toned underpainting, I worked with layers and glazes, reserving the thickest paint for the lightest areas. To define the shape of the London Eye, on the left, I concentrated on the negative spaces: by carefully placing the areas of pale blue light seen behind the structure of the Eye, this in effect created its shape. Of course there are other techniques that are all part of the painting process, including wet-into-wet, blending, dry-brush and scumbling.

Style and integrity

If you agree that one of the reasons for painting is to share ideas with other people, then ideally you will want to work in a style that truly reflects your personality. No doubt like most artists you would like to establish a style that is distinctly your own and which readily identifies your paintings, but it is best not to be too anxious or impatient about this. Style is not something you can force or consciously create in some way. It has to evolve quite naturally. If you begin to paint with an obvious awareness of style and a concern about being 'recognized', there is sometimes a temptation to impose the styles of other artists on your work rather than focus on a genuine reflection of your own feelings. Ultimately, such an approach is bound to prove unsatisfactory, because undoubtedly the most successful and rewarding paintings are those that have an inherent integrity.

An artist's style results from a combination of factors – practical matters, such as the chosen subject matter and the media and techniques used, but also an individual way of seeing and reacting to things. The best approach is simply to keep painting, while ensuring that you concentrate on ideas that excite you, and that you reflect that excitement in your work. There may be a phase of work or even an individual painting that marks the

turning point and establishes the qualities that eventually provide the foundations of your style, but this is not always apparent at the time. It is noticeable in retrospect. When I look back over my work, I can now identify a period when my style began to emerge.

Travel

I enjoy travelling and finding new subjects to paint. People who see my work at exhibitions often recommend places that I should visit and, when I add these to the locations I already have in mind, there is a long list awaiting my attention! So I will never be short of subject matter and, for me, travel is an essential part of my working process. Many of my ideas have come from the landscape and towns of the Mediterranean – at locations in France, Italy and Majorca. I have worked quite a lot in Venice, where I generally look for subjects away from the most obvious sites. Now, having painted in London, Paris, Rome, Amsterdam and New York, I can see the potential for visiting more cities in the future. Currently, in Britain, my main subjects are the coast and beaches of the south-west, together with pastoral landscapes, many of which were initially inspired by a series of paintings of the River Avon.

Of course, there is no need to travel on a global scale to find interesting subjects to paint – they are everywhere. What is more important is that you experience a subject and

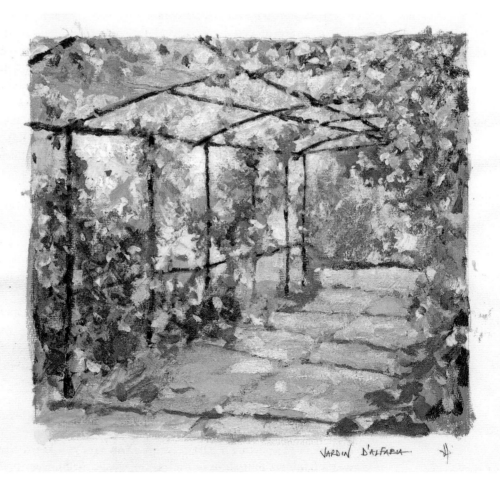

Jardin d'Alfabia
acrylic on paper
22.5 x 24.5 cm (9 x 9¾ in)
Sometimes I make a study like this, in which I examine both the colour and textural qualities in the subject matter.

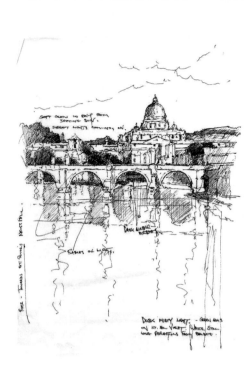

Lyme Regis
pen and ink on 300 gsm
(140 lb) watercolour paper
30 x 38 cm (12 x 15 in)
Pen and ink is my
preferred medium for
quick reference-gathering.

Towards St Peter's
pen and ink on
cartridge paper
30 x 21 cm (11¾ x 8¼ in)
With added written notes,
even a black-and-white
drawing can help with
information about colour
and light.

initially are able to work from first-hand information and observation. So, if you are unable to, or do not wish to travel abroad for some reason, I am sure you will discover equally inspiring and challenging subjects much closer to home. Explore your local area and see what you can find. And remember to try some new subjects as well as familiar ones – it is good to step outside your 'comfort zone' now and again.

Whether you travel just a few miles down the road or decide to make a trip to Provence or Tuscany, it inevitably takes a while to develop the sort of knowledge and understanding of a new location that will enable you to paint it with real feeling and confidence. In fact, this is precisely why I enjoy visiting new places. There is immense satisfaction in unravelling the particular qualities and characteristics that make a place unique. I usually start with some brief notes and sketches. These help me focus on the key elements – things that impress me as the most meaningful and interesting about the subject.

I enjoy the contrasting challenges of the city and landscape subjects but obviously the process of collecting reference material can be quite different between urban and rural locations (see Practical considerations, in Working on site, page 42). Something I have also grown used to, when painting in different countries, is the need to adjust my palette to suit the particular light quality and its influence on the colour key for the subject matter. I basically keep to the same selection of colours – titanium white, cadmium yellow light, cadmium yellow medium, cadmium red light, cadmium red medium, yellow oxide, Van Dyke red hue, light blue violet, dioxazine purple, cerulean blue and phthalo blue – but as required vary the way I mix the colours and juxtapose them within a painting to create the necessary intensity and effect.

Interestingly, I have also noticed that each location seems to have what I would call its own signature colour – a certain colour that quite discreetly creeps into every subject somewhere. For instance, in Amsterdam the colour was a kind of burnt red/orange, touches of which would appear on shutters, awnings and suchlike. Very often the 'signature' colour is not something you notice until you have completed a group of paintings and have had time to reflect on them.

Setting out
Although in selecting a particular location you will know roughly what to expect in the way of subject matter, nevertheless try to approach every painting trip with an open mind

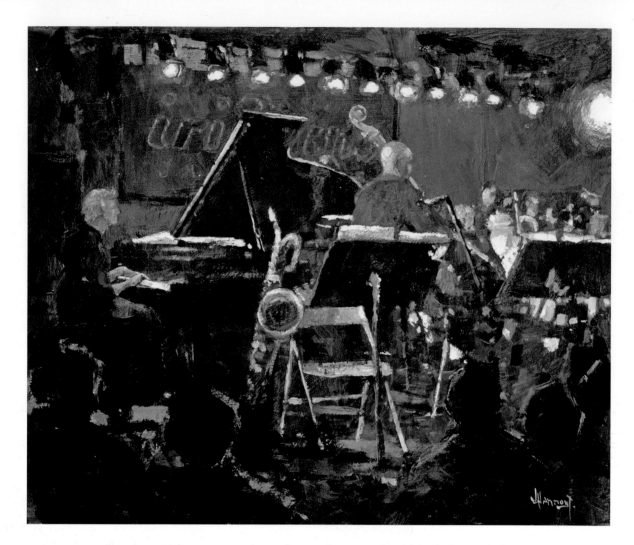

Iridium Jazz, New York
26 x 30 cm (10¼ x 12 in)
You can never be entirely sure what you will find in the way of subject matter. In New York, for example, I had expected that all the best subjects would be on a grand scale, but in fact the ideas that interested me most were quite intimate scenes, as here.

rather than with preconceptions about what you should look for and choose to paint. In my experience, often the most successful subjects are the least expected ones. It is a matter of being receptive to potential ideas and not being afraid to tackle them, even if they are quite different from the type of subject matter that you normally prefer. When I went to New York, for example, I naturally thought that the most impressive sights would be the skyscrapers and that the sheer scale of the city would suggest large paintings. But to my surprise, I found that the mood of the city was best captured at night, on the busy streets and in more intimate scenes, as illustrated in my paintings of jazz clubs and skaters (see above and page 56).

The amount of planning for a trip will depend on a number of factors: the location (landscape, city, etc.); whether you have been there before; the means of travel, and thus the amount of equipment you can carry; and the accommodation, which will determine the scale and scope of the work that you can do indoors. For a first visit to an area, I advise you to travel light and rely principally on making sketches and perhaps taking photographs. When I go to a new location, essentially I devote that initial trip to exploration, getting to know the area, and covering as much ground as possible. I make notes and brief sketches in my journal – details of places that offer potential for different subjects, along with other observations, such as the best time of day or season of the year in which to make a return visit. This enables me to focus on certain painting sites when I return to the area, although as I have mentioned, I will not be going with any specific ideas in mind. Indeed, always my main aim is gathering information – reference sketches, colour notes, photographs and so on – that will provide me with plenty of ideas to work

from when I get back to my studio. Given time and the right conditions I will begin, and sometimes complete, paintings on the spot, but obviously these tend to be quite small works, probably no larger than 40.5 × 40.5 cm (16 × 16 in).

Indeed, time is the most valuable asset, so generally I would much rather spend several days compiling reference information that might eventually lead to, say, a dozen paintings, than concentrate on just a couple of finished paintings made on site. Also, there are so many variables when painting on location: you can never be quite sure of the light, weather and so on. Therefore you have to be willing to adapt to the conditions and, if necessary, abandon one idea and move on to something else.

However, there is no denying that paintings made on site have a freshness and immediacy that is very difficult to emulate in the studio. Look at *Low Sun, Venice* (below) and *Sparkling Light, the Basilica* (page 26), for example. Both of these were painted on the spot. In fact I intended them to be quick working studies, but everything went so well that they developed into finished paintings in their own right. I was

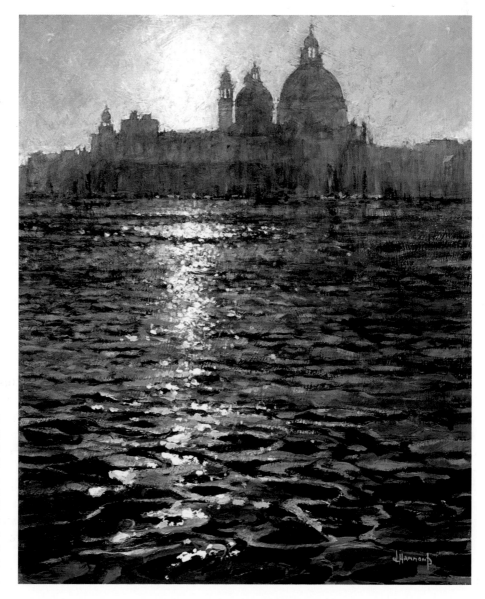

Low Sun, Venice
40 x 32 cm (15¾ x 12½ in)
Although I never set out with the specific intention of finishing a painting on site, conditions sometimes work completely in my favour and I am encouraged to carry on painting – with only a few modifications necessary when I reassess the work back in the studio.

especially pleased with the light effect in both paintings. The special quality of light in a subject is always something that fascinates me.

Scope and variety

With a little experience, you soon realize which type of subject matter works for you and which is less successful. Not every subject will suit your style and approach, so essentially you should concentrate on those ideas that excite you and which you feel an affinity for. However, try to combine fresh challenges with the familiar themes, for there is an infinite variety of subjects to choose from. And remember that what matters above all else is that you paint with feeling; that you are not afraid to express ideas in a personal way, emphasizing those aspects within the subject that you regard as important.

Landscapes

As in *Riverside* (opposite), rather than painting remote wilderness subjects, I am mainly interested in landscapes that in some way imply the influence of man. Essentially, my aim is to capture the special sense of place that each landscape conveys. To help achieve this I start with sketching, observation and taking note of associated factors such as weather conditions, sounds and smells. In this way, back in the studio, I can relive my experience of the scene and aim to recapture the mood and the particular quality of light that originally made the subject so distinctive and appealing.

In addition to resolving the composition of a landscape subject, which usually relies on finding an interesting viewpoint and selecting from a much wider scene (see Design, pages

Riverside
50 x 61 cm (19¾ x 24 in)
Landscapes do not
necessarily have to be big,
open spaces. Often the
most interesting paintings
result from concentrating on
just a small section of a
landscape scene, as here.

Devon Pasture
50 x 61 cm (19¾ x 24 in)
This quintessentially English
pastoral scene is a subject
that I think many people will
relate to.

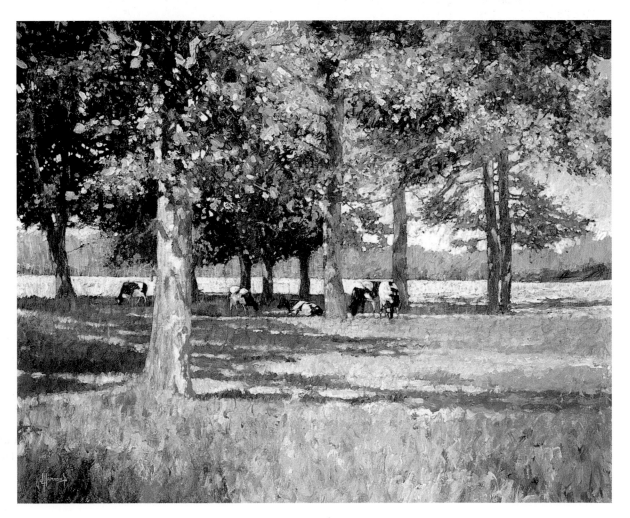

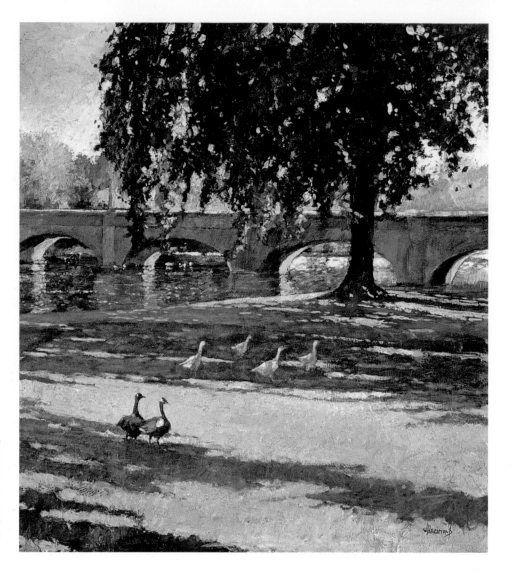

Shady Bank, Stratford
46 x 41 cm (18 x 16 in)
There are many different types of landscapes to explore, as in this painting, which was inspired by a riverside view at the edge of a town.

58 to 73), one of the most difficult aspects is expressing a convincing sense of space, particularly with regard to creating an effective transition from foreground to distance. The various devices that artists normally use to suggest space and distance in a painting include changes in scale, aerial perspective, linear perspective, colour relationships, different painterly qualities, and contrasts between defined and less defined areas.

Therefore, in theory, the foreground area will include bolder colours and more detailed treatment than used for suggesting distance, although as with all 'rules' and conventions in painting, the opposite can work just as effectively. For example, in my paintings the principal area of interest is often the middle ground, and I treat the foreground in a broader, less detailed way.

To help evoke the particular environment and sense of place, I will often include a large foreground area with just sufficient interest to entice the viewer into the painting. I like the idea that the viewer can, in a sense, wander through the foreground space and discover whatever is happening beyond. In this way, the foreground provides a context for the painting, while another advantage is that I can introduce perspective and different forms of mark-making here, which will create a strong sense of depth. As in *Shady Bank, Stratford* (above), a bold cast shadow is often a good way to add interest to the foreground and lead the eye into the painting. This painting also exemplifies how I prefer the foreground to be uncluttered. It is a vitally important part of the composition, but care must be taken to ensure that it looks natural rather than contrived.

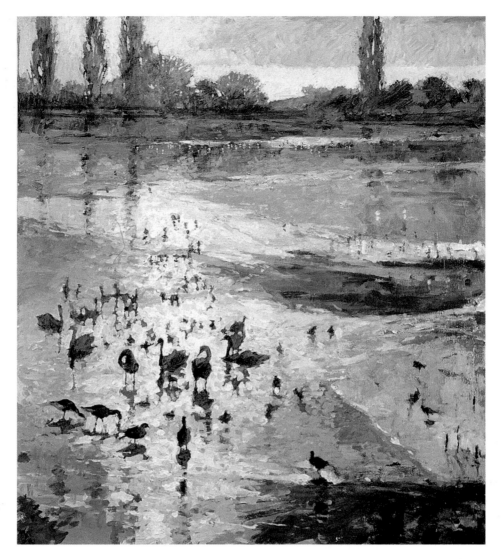

Morning Ice, Slimbridge
90 x 80 cm (35½ x 31½ in)
The appeal of this wonderful
winter scene was the way
that the light was reflected
by the ice and water.

Water and reflections

Water is one of the most challenging subjects to paint because, rather like the sky, it is a very changeable and telling part of any landscape view. In reflecting and perhaps even defining the quality of light, a stretch of water will reveal much about the mood of the subject. Consequently, capturing the character of the water is fundamental in successfully evoking the atmosphere of the scene and the sense of time and place. Again, observation is the vital starting point. I like to spend some time just watching the surface of the water and trying to understand its rhythms and patterns. Also, I look to see whether the surface is rippled, smooth, dark, light and so on. From these observations I can decide which colours and painting techniques will be most suitable to convey the appropriate effects.

Understandably, many people assume that water must be painted with very liquid colours. Yet while this might be true when using watercolours, it is certainly not essential with acrylic paint, which offers far greater freedom and control. Ripples and reflections can be painted in much the same way that you would paint any other surface, perhaps using quite textural paint as well as glazes to create depth or transparency. Incidentally, I regard reflections as an integral part of the water surface rather than as features that underlie the surface or are superimposed on it.

An advantage of acrylic paint is that you can continually adjust the colours and brushwork until you have the effects you want. Note that in *Morning Ice, Slimbridge* (above) I have used a fairly dark underpainting, which has been left as the basic colour

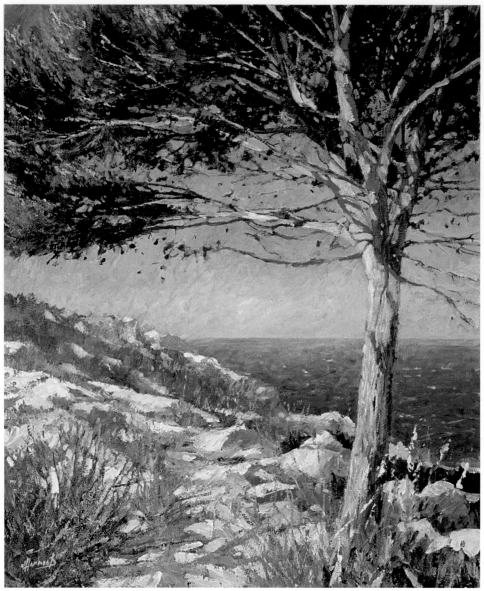

Coast Path, Majorca
61 x 50 cm (24 x 19¾ in)
Here, the principal challenge
was in creating a sense of
distance across the
expanse of blue
Mediterranean sea, which is
achieved mainly through
tonal and textural changes.

for most of the birds. The surrounding light areas contain a lot of heavy impasto work, modified with subsequent glazes to create subtle changes of colour.

Coastal subjects

Estuary and coastal scenes offer tremendous variety, both for atmospheric, expansive views and for more intimate subjects. Two contrasting approaches are demonstrated in *Silver Light, Topsham* (opposite, top) and *Gentle Progress* (opposite, bottom). You can see that in the first of these examples, the horizon is placed low down, creating a much greater sense of space and an inevitable emphasis on the sky area. On the other hand, in *Gentle Progress* the horizon is higher, which shifts the action to the foreground and produces a more compact although equally evocative subject. And, as in *Beach Games* (page 32), I also enjoy painting coastal subjects that involve figures, whether it is people enjoying themselves on the sands or fishermen preparing their nets or landing their catch.

For painting skies, I adopt a similar approach to the one that I use for painting water. If there is a big expanse of sky, then obviously I want it to be interesting and to contribute in a positive way to the impact of the painting. Essentially this means carefully observing the cloud formations and making the most of contrasts of light and colour. It is not possible,

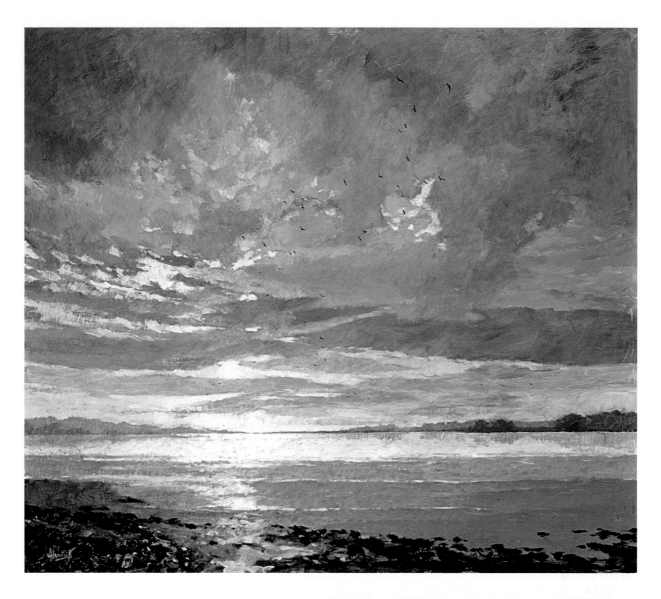

Silver Light, Topsham
80 x 90 cm (31½ x 35½ in)
Perhaps especially in an open landscape
such as this, you need to think carefully
about the composition and how to
develop a 'journey' for the viewer to follow
through the painting to reach a focal point.

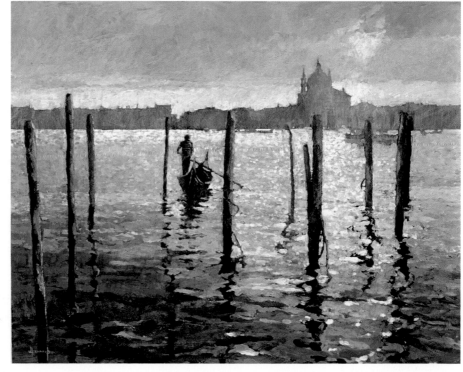

Gentle Progress
50 x 61 cm (19¾ x 24 in)
Here again, the sense of distance across
the water is achieved by using quite a
dramatic change of tone and brushwork
from foreground to horizon.

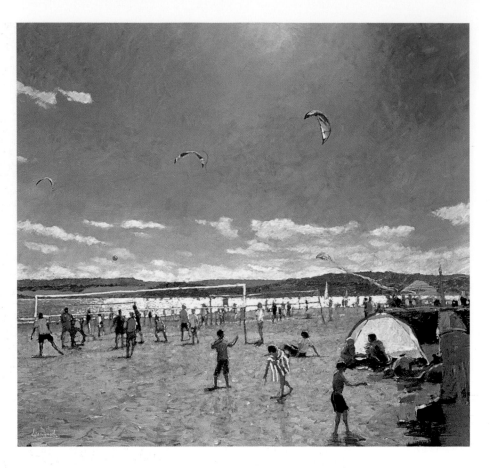

of course, to copy a sky exactly, because of its transient nature. But in studying it for a time and trying to understand the cloud shapes and the way that they move, I know I am more likely to create a sky that is convincing. It is this knowledge that will allow the confident use of a free and more expressive painting style, and here again acrylic proves a very forgiving medium, allowing areas to be altered and reworked as necessary.

Street scenes

The effectiveness of every painting relies to some extent on the quality of the underlying drawing and the way that different shapes and forms create a certain structure for the work. With buildings and street scenes in particular, a concern for drawing is extremely important because it is always very noticeable if the main shapes lack conviction. Yet this need not mean that the buildings have to be depicted in every detail, perhaps as an architect would show them. As always, it is a matter of capturing the essence of what is there – the shapes must look credible and relate to the actual scene; nevertheless the approach and painting style can be just as atmospheric and emotive as those inspired by other subjects.

So, with an ornate façade for example, there is no need to include every window and detail. But the overall proportions and the main characteristics must be right, as must the angles and perspective. An understanding of perspective is essential. Use it to inform your drawing, rather than allowing it to dominate the process. Working with precise guidelines, vanishing points and so on tends to give a very stylized, unnatural-looking result.

In a view such as that shown in *Gentle Sunlight, Leaving the National* (opposite, top) you can see how the influence of perspective is important in creating the right degree of scale and depth. Notice also the inclusion of figures in this composition; they add interest and a sense of movement. Another important element in street scenes and architectural subjects is the use of light and shade. This can be a key factor in defining shapes and creating the illusion of three-dimensional forms. See also *Over Assisi* (opposite).

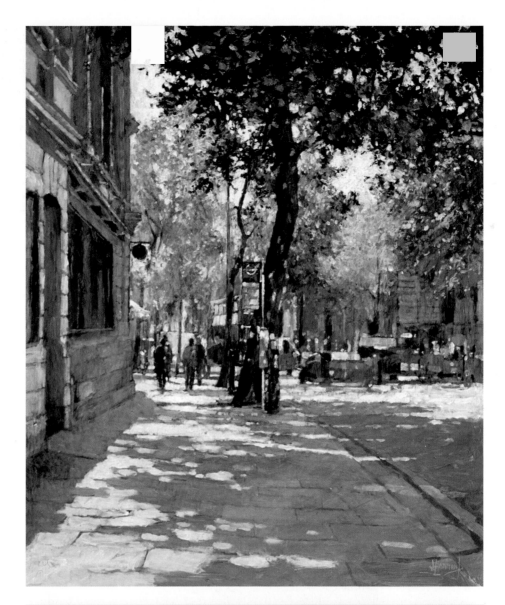

Gentle Sunlight, Leaving the National
61 x 50 cm (24 x 19¾ in)
Light and mood are everything in a subject. In this London street on a Sunday morning, the mood was quiet and entirely different from the hustle and bustle of a weekday.

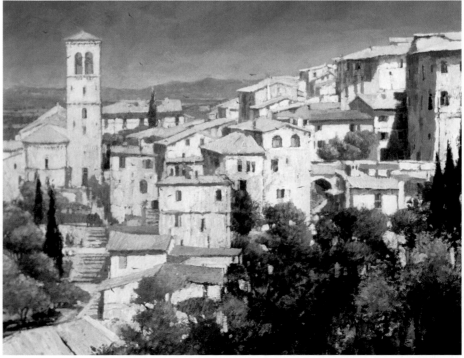

Over Assisi
55 x 70 cm (21½ x 27½ in)
To underpin the composition in this type of subject, selection and draughtsmanship are always essential factors.

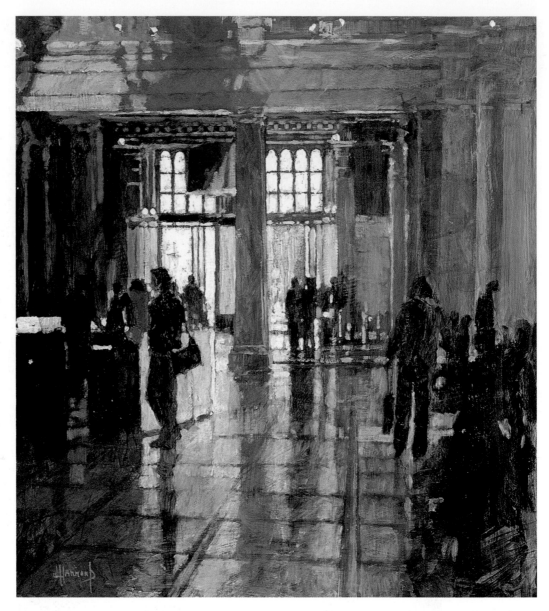

Coloured Shadows, V & A
39 x 34 cm (15¼ x 13½ in)
One of the things that I especially enjoy about painting interiors is the contrast between the artificial light and the ingress of natural daylight.

(Opposite)
Admiring Bernini, St Peter's
61 x 46 cm (24 x 18 in)
Making sketches or taking photographs inside a religious or historical building is subject to certain restrictions – so do check what is allowed.

Interiors

This is a relatively new subject area for me. In the main, my interest in interiors has developed quite naturally from my visits to different cities and towns, where it has been difficult to resist exploring the historical and architectural sights on offer. Usually the attraction of interiors is that the mood and lighting are more dramatic than in other subjects, the space more confined, and while they may not provide a set narrative as such, there is normally plenty of human interest and activity. Something else that can be particularly exciting is when the interior includes a polished marble or stone floor. This creates wonderful reflections and very striking compositions to paint.

Each interior has a function, maybe as a place of worship, a museum or a gallery, so I try to capture a feeling of that in my paintings. As always, I make some sketches on the spot and, if permissible, take photographs. Additionally, the acoustics of an interior – the footsteps, echoes and people talking – are very emotive qualities that help recall the scene when I am back in the studio. *Coloured Shadows, V & A* (above) is typical of the sort of interior I like. What particularly excited me about this subject, as the title suggests, was the way that the light from the huge chandelier was reflected across the floor area, adding colourful, elongated shadows to the figures.

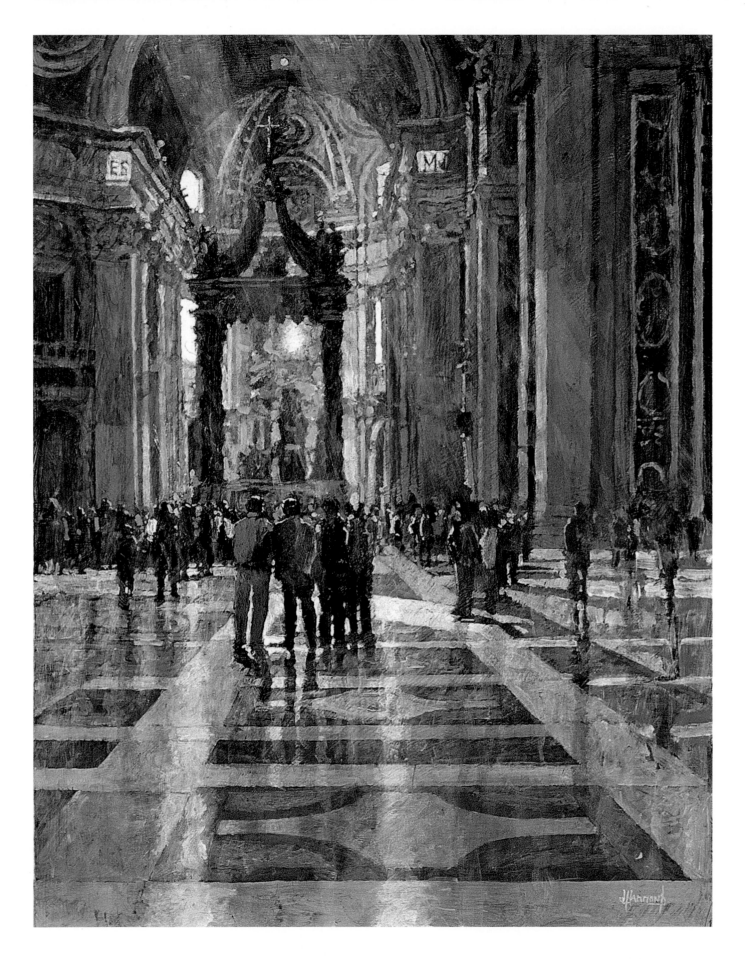

Figures

Figures give a sense of scale to a composition and add interest and movement. As in *Silvery Notes, Pienza* (below), a person can be the focal point, the inspiration for a painting, or alternatively a group of people can play a less dominant yet nevertheless important role in contributing to the mood and impact of a more complex scene, as in *Parasols, Tuileries* (opposite). Figures are one of the most difficult subjects to master, so plenty of observation and sketchbook work is essential. My sketchbooks are full of little figure studies, and I know at some point these will prove invaluable when I want to include some people in one of my paintings.

Silvery Notes, Pienza
30 x 26 cm (11¾ x 10¼ in)
In this painting the figure is the most important element of the composition and is quite specifically painted. Compare this to *Parasols, Tuileries* (opposite).

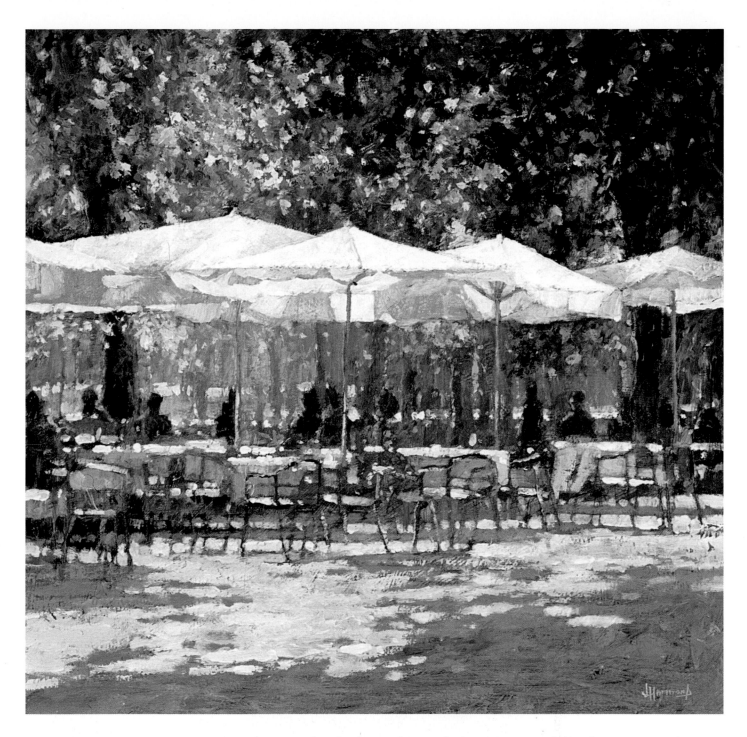

It is important that the figures fit in with their context and that they are painted in a way that is consistent with the rest of the work. Because we are so aware of how people look – with a head, two arms, two legs and so on – it can be tempting to try to include such information within every shape. But to paint or draw figures convincingly, we need to forget these preconceptions and rely instead on careful observation. If you paint what you see, rather than what you believe to be true, your figures will have a more believable form. This is particularly evident when painting distant groups of figures. It is the overall impression that counts, and this may mean that some figures are suggested with maybe just a single brushstroke – look at the background figures in *Silvery Notes, Pienza*, for example. Quite often when I paint a crowd I pick out one or two figures in a little more detail, and these help inform the rest.

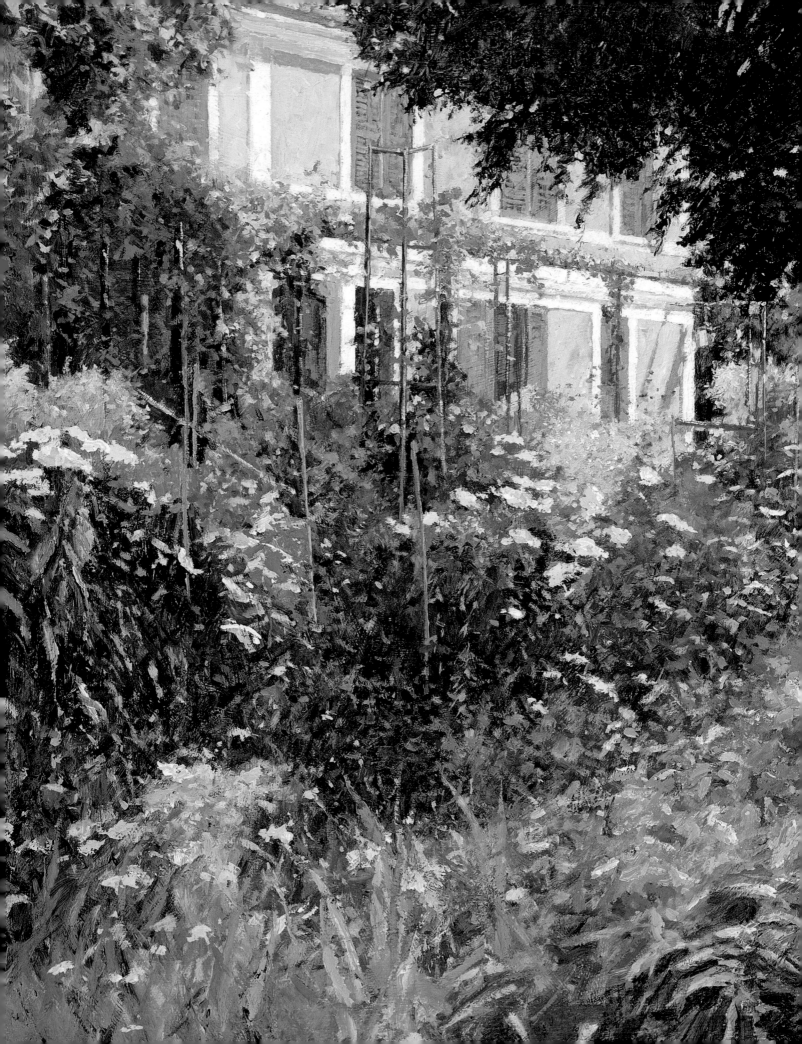

PICTURE PROFILE

The Artist's House, Giverny

In many ways, this painting typifies my working process and demonstrates quite a few of the points covered in this section. It is a fairly recent studio painting which, as in all my work, was developed from observations and reference material produced on site. For some time I had been considering the idea of painting a garden subject in the spirit of the great Impressionists. And as Monet is one of the artists that I admire most, his garden at Giverny seemed the obvious, if perhaps most daunting, place to start.

I went with a completely open mind, not knowing whether I would find an idea or not. But Giverny is such an incredible environment that as soon as I arrived I had no doubt that I wanted to paint there. It is a very special place, charged with a strong visual excitement from the riot of colours, forms and textures; the knowledge that Monet designed everything and painted there also gives it an underlying emotive quality.

This particular scene is quite near the house, where the display of flowers was at its best. I chose this view because I felt that the façade of the house, together with the two dark trees on the right, added a strong structural element to the painting. In turn, this created a nice contrast to the more textural, colourful and expressive treatment inspired by the dense array of plants in the foreground. I will certainly return to Monet's garden and the experience of this painting has encouraged me to consider other gardens and man-made landscapes as potential subject matter. These views, with their large, colourful flower borders, offer a fascinating challenge, and there is plenty of scope to explore the expressive and abstract qualities of painting.

The Artist's House, Giverny
61 x 70 cm (24 x 27½ in)

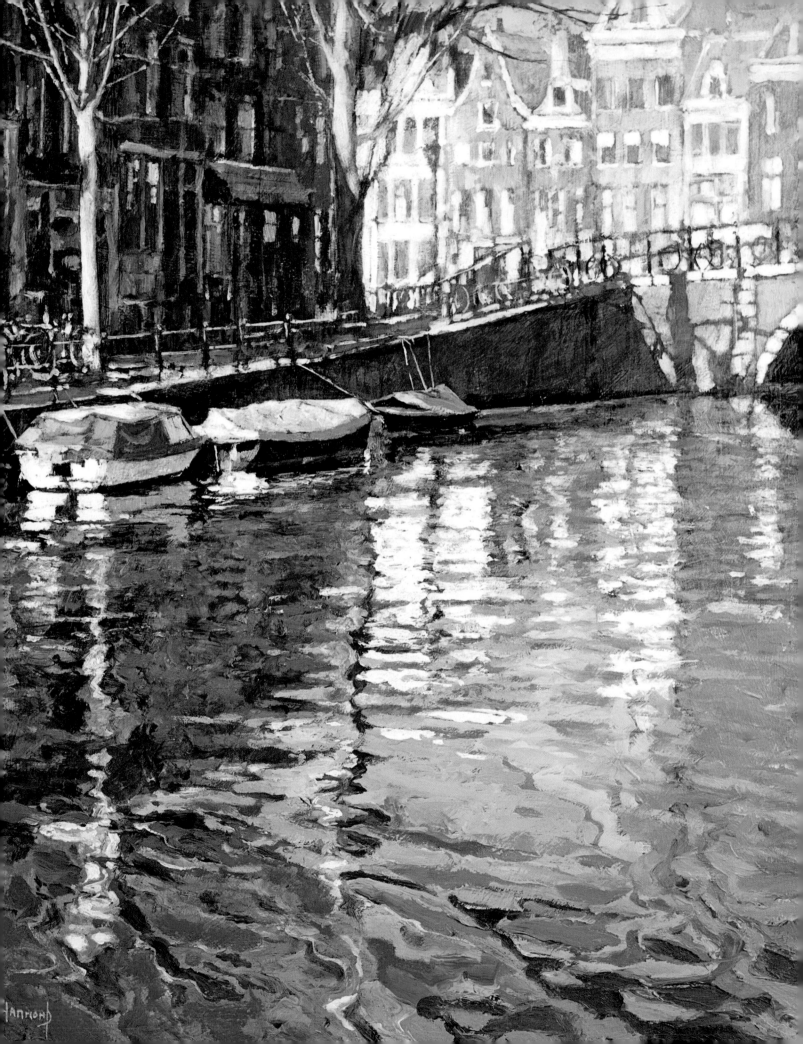

2 *Reference Material*

Occasionally I make a painting entirely on site, but as I have explained, my preferred approach is to work in the studio, referring to the drawings and other information gathered on location. In my view, there is no better way to explore the potential of a subject, and at the same time develop a real understanding and feeling for it, than to make a sketch. However, it is vital that the sketches provide the right sort of information from which to create a successful painting later. Knowing what to look for and record is part of the skill, and something that only comes with experience. As well as recording the basic composition, I always include information on colour and light in my sketches, add any written notes that I think will be useful, and jot down points that will help me remember my emotional response.

Working on site

I could never work only from photographs because I think such an approach is too divorced from the actual subject matter. Interestingly, the more I paint, the more I find it important to experience that initial observation and contact with the subject – it has

Drawing at Monteriggioni.

(Opposite)
Ruffled Water,
Spiegelgracht
50 x 41 cm (19¾ x 16 in)

become a vital part of my working process. The most obvious advantage of working on site is the sense of immediacy, the fact that you can react and respond directly to what is there. This encourages an honesty in the work, because essentially you are relying on what you can see rather than what you imagine or assume you know about the subject.

Travelling light

When planning a painting trip, try to be realistic about what you are likely to achieve, and choose the materials and equipment accordingly – there is little point in being overburdened with non-essential items. Usually, the two main factors that influence the amount of equipment you take are the timescale involved and whether there will be any opportunities to work inside. In general, I would advise travelling with as little equipment as possible. However, if you are planning to go away for some time and are thinking of renting studio space or self-catering accommodation, then obviously you will be able to work on larger, more resolved paintings. In that case, you will need to take the necessary boards or canvases plus any additional equipment required for them.

I take different types of painting kit, depending on where I am going and the form of transport. For instance, if I am flying I choose a lightweight painting set that packs away into my suitcase. On the other hand, if I am travelling by car I normally take more equipment, including a few larger painting boards, up to 40.5 × 40.5 cm (16 × 16 in). These are quite thin MDF (medium-density fibreboard) boards prepared with two coats of acrylic primer. For other on-site work I generally paint on small pieces of cardboard prepared in the same way or perhaps make a colour sketch in a Cryla pad or use a similar type of sketchbook made for acrylic painting.

For my usual style of work, I tend not to mix the paint with water. But to clean my brushes or to paint more in the manner of watercolour I need a plentiful supply of water, so I take a fairly large water container – the sort that you would buy in a camping equipment shop. The brushes and paints are a reduced version of those that I use in the studio – fewer brushes and smaller tubes of paint. Additionally, I sometimes take a lightweight folding aluminium easel, although quite often I just find somewhere to sit and paint with the board propped up on my knees. All of this equipment fits into a rucksack, making it easier to carry across difficult terrain.

Practical considerations

Before I start sketching or painting outdoors, I like to make an overall assessment of the situation and then decide on the type of work I think is achievable within the next hour or two. Work made *en plein air* (in the open) demands a lot of concentration and in my view, after about two hours it is essential to take a break. Also, I find that this sort of time limit encourages a focus on the important qualities in the subject matter and helps prevent the drawing or painting from becoming overworked. Therefore my advice is to spend a little time checking such things as the movements of people and traffic, the quality of light, and the general weather picture and how this might change. More than once I have been sketching on a beach only to suddenly become aware that the tide has raced in and is lapping around my feet. So, if like me you enjoy beach subjects, do check the tide first!

Assuming the conditions are promising, all that remains is to decide on the exact viewpoint from which to work. Here again, it is necessary to take into account any

My painting equipment for working on site.

On my way to a painting location, with all my equipment in a rucksack.

practical considerations, and this may well mean that you have to compromise concerning the best spot to choose. For example, if you want to sketch at a popular public place or at a well-known historical or architectural site, it is wise to look for a doorway, corner or similar spot where you can work relatively undisturbed. Out in the landscape it is much easier to find a quiet place to work from, but in towns and cities there is often a certain amount of intrusion from inquisitive passers-by.

Obviously another problem when working outside is that the weather can change quite dramatically and unexpectedly, even in the summer. However, unless faced with a severe thunderstorm or perhaps a sudden snowstorm, it is usually possible to adapt to the situation and produce something worthwhile in the way of reference material, even if this is wet and smudged!

Heat and cold are other factors that can influence the type of work undertaken. It is difficult to sketch or paint for any length of time in very hot or very cold conditions, and the temperature can also affect the handling properties of the paint. Because I work quickly, I am not too concerned if the paint dries faster than normal when the weather is hot, although I do take more care about the quantities of paint I put out on the palette and ensure that brushes are immersed in water when not in use. Some artists add a small amount of retarder (a translucent gel that will extend the drying time) to the paint when working in hot conditions, but this is not something that I do.

Media and methods

I rarely set out with the exclusive aim of producing a finished painting on site; that is not my priority. For me it is more important to gather as much reference material as possible, so I mainly concentrate on sketches, notes and a few colour studies. Additionally, the transient nature of the subjects that interest me, together with the fact that I am always keen to move on after about two hours to explore new possibilities, means that usually there is not enough time to undertake a set painting. When working on location, I

Painting at a window – it is good to find a vantage point where you will be undisturbed.

Boy Sam at Budleigh Salterton
pen and wash on watercolour paper
41 x 30 cm (16 x 12¼ in)
I sometimes use a water-soluble pen, which will give me additional tonal values when areas are wetted with a wet brush, rag or finger.

typically divide the day between exploration, which helps me gain a better knowledge and understanding of the place, sketching and making a note of other sites that look promising as potential subjects for paintings.

However, sometimes I will start a colour study in acrylics and because everything is working so well – the subject matter, conditions and flow of the painting – almost unintentionally the study will develop into a finished painting. But mostly I sketch with pencils or fine fibre-tip pens. I often carry a big bunch of these pens held together with an elastic band. What I particularly like about pen-drawing is that is has an immediacy. Because you cannot rub out the marks or alter them in any way, it concentrates the mind and the drawings have a real sense of that first-hand experience of the subject. In contrast, pencil allows a more considered result. Both media are useful for making drawings that focus on tonal reference and general information about the subject matter.

For the colour notes I used to work with coloured pencils, although these can only give an approximate guide to the colours required. Another option is to make some quick acrylic sketches on paper, but now I mostly rely on my memory and written notes. Having used the same palette of colours for many years, I now find that I can simply jot down a series of 'recipes' for the colour mixes I think I will need in the actual painting.

Sketches and drawings

I regard sketching as one of the most important aspects of the working process. For me it is the ideal means of capturing my initial reaction to a subject and recording the momentary sense of time and place. In turn, such reference material is invaluable for informing the paintings and creating work with real feeling and impact. The advantage of

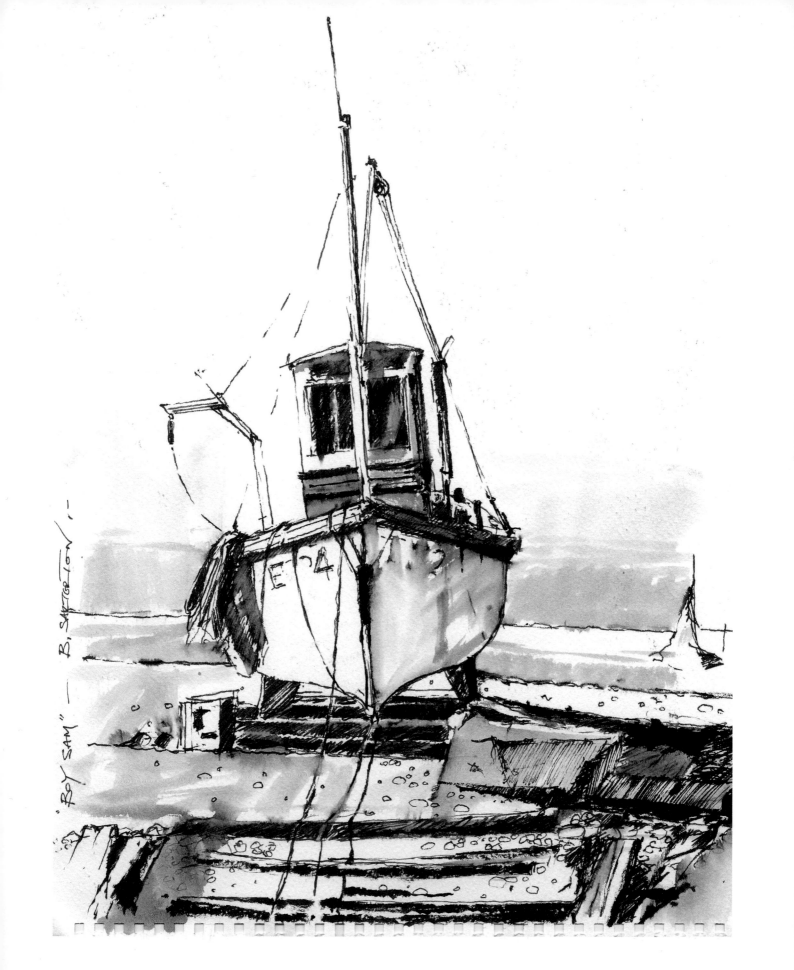

"BoY SAM" — B. SHEPPERTON —

sketching is that, unlike painting, it requires very little in the way of materials – just a small sketchbook and a pen or pencil. So you can sketch anywhere, and this is what makes it such an incredibly useful technique. Also, sketching helps train your powers of observation; it encourages you to look and make judgements about what you see.

If I come across a potentially interesting subject to paint and I do not have my sketchbook with me, the only option is to make a mental sketch of the idea. I sit in front of the subject and try to commit to memory all the key points about it. With increased experience, this is now something I can do quite successfully. It is a matter of gradually training your visual memory to retain a 'picture' of the subject, with its main features. Then, back in the studio, you can make a satisfactory reference sketch from everything you have remembered.

Using a sketchbook

Naturally the type of sketchbook you choose will need to suit the sort of media and techniques you intend using. Sketchbooks are sold under a variety of names, such as sketch blocks, drawing pads, layout pads, study pads and so on. They also vary in size, whether they are glued or spiral bound, and the type of paper they contain.

When buying a sketchbook, the two main considerations are size and the type and quality of the paper. If you want to work in a variety of media, an A4 (210 x 297 mm, 8¼ x 11¾ in) spiral-bound sketchbook with sheets of 185 gsm (90 lb) watercolour paper is a good choice. The advantage of this particular type of paper is that it is not too rough in texture and therefore is fine for dry-sketching methods with pencils, pastels and charcoal, as well as wash or watercolour techniques. Lightweight cartridge paper is good for pencil sketches but will prove inadequate for watercolour washes.

My sketchbooks and journals are small and lightweight – I like a sketchbook that can easily be held in one hand. In fact, most of my sketchbooks are Italian leather-bound ones. I buy these partly because they are such lovely objects, which encourages me to use them. I prefer a portrait format, which is easier to hold. For any large sketches, I work across a double page. I never buy anything bigger than A4 and I combine these with some much smaller, pocket-sized books in which to make very quick sketches and notes.

A selection of my sketchbooks.

Sketching equipment.

One of my leather-bound sketchbooks, showing how I often work across a double page and add various written notes.

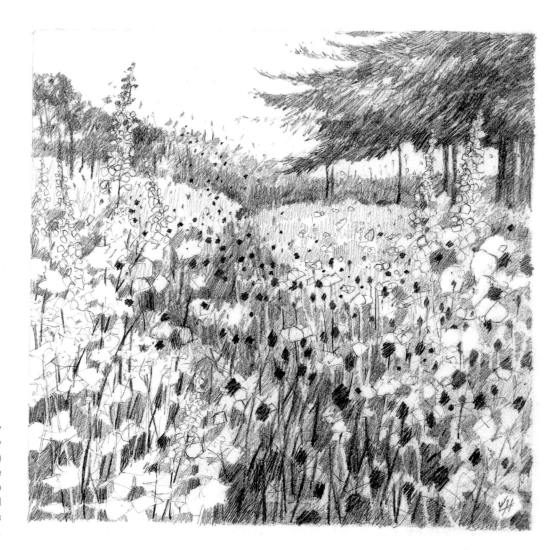

Meadow
pencil study
23.5 x 24 cm (9¼ x 9½ in)
Making a pencil study like
this is a very good way to
get to know a subject and
assess its potential for a
possible painting.

Ideas and information

The reason for making a sketch will obviously vary depending on the circumstances, subject matter and information required. For example, the aim might be to investigate a particular quality such as tonal values, or you may want to make a sequence of small sketches to try out different viewpoints and alternative compositions. How successful the sketch is will in part depend on choosing an appropriate medium or technique. Sometimes a sketch might be just a few quick lines to plan something out or capture the essence of an idea, while on another occasion you may need to make a much more finished drawing for detailed reference. From brush drawings and felt-tip pen sketches to using charcoal pencils or Conté crayons, there are all sorts of media and techniques to choose from. My advice is to try out as many of these as possible, and in that way you will find the best methods and approaches to suit your style and the type of information-gathering you need.

The most important thing is not to be afraid to use your sketchbook in a free and confident manner. Remember, it is your personal visual notebook – you do not have to show it to anyone else, so you can be as bold, expressive and individual as you wish. It does not matter if you make mistakes or produce what you feel are bad sketches. What matters is that you record information that means something to you personally. Many ideas might not be considered to be finished studies or necessarily lead to a completed painting, but every sketch will add to your experience and teach you something about observation and drawing techniques.

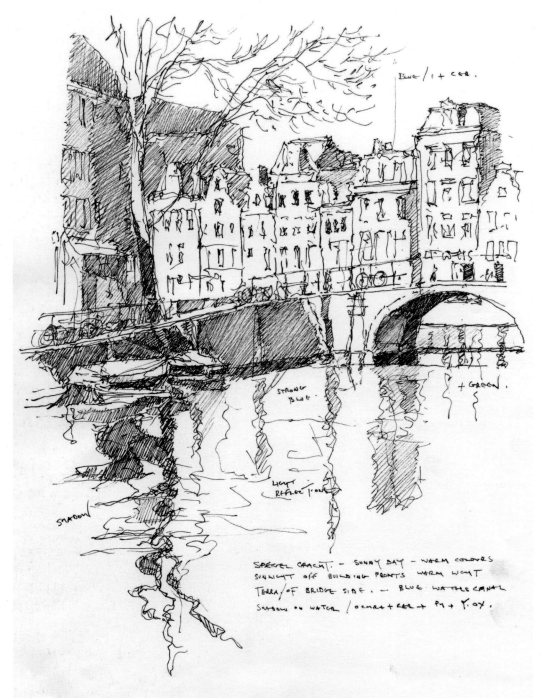

Ruffled Water, Spiegelgracht
pen and ink on cartridge paper
25 x 20 cm (10 x 8 in)
For me, the first step in reference-gathering is usually to make a pen and ink sketch like this, with added written notes.

At a new location, time permitting, you will probably find that you will want to start by making some fairly detailed drawings in your sketchbook. This is usually my approach when I first visit a place, and a good example is the sketch for *Ruffled Water, Spiegelgracht* (see page 40 and above), which I made on my first visit to Amsterdam. Until you have some experience and understanding of a particular location and the type of subject matter, try not to be too selective in your information-gathering. In my view, the best way to acquire a deeper knowledge is to start with some quite resolved drawings that help explore the subject matter and enable you to define the qualities that most interest you.

When I return to my studio after a painting trip, I like to spend some time looking through all the material and re-familiarizing myself with the various ideas. I seldom work from a single sketch. Usually, I compose the painting from a body of reference material

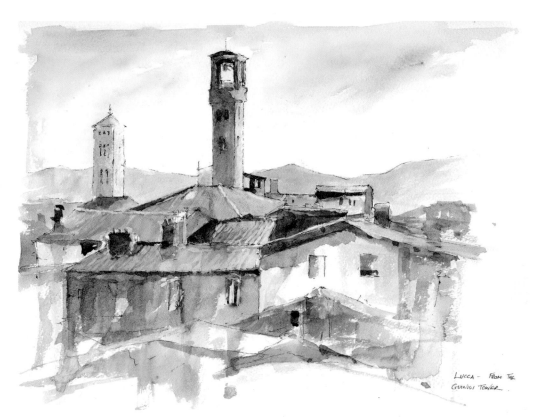

Lucca
pen and acrylic wash on
watercolour paper
30.5 x 38 cm (12 x 15 in)
For this type of reference
sketch, I start with the line
work and add colour
washes made by diluting
acrylic paint with water.

Soller
25 x 22 cm (10 x 8½ in)
acrylic on textured
acrylic painting paper
Using thicker paint on
acrylic painting paper, I am
able to get an initial feeling
for the subject and how well
it will work in the studio.

that also includes notes and photographs. I like the composition to develop organically and therefore I normally draw directly on to the prepared board itself, rather than copying or transferring a drawing that I have already made.

Photographs

As well as carrying a sketchbook with me wherever I go, I usually also take a camera. Certainly, on my painting trips abroad, I find the camera invaluable as a supplementary means of recording information and, of course, there are occasions when time is very limited and therefore photography is the only option. However, while photographs can be extremely helpful, they do have their limitations. So, in general I regard them as a supporting aid and never as a substitute for sketching, which for me is always the best way to capture the essential qualities of a subject.

Advantages and limitations

On my painting trips I naturally want to compile as much reference material as I can within the time available. In this respect there are certain subjects for which photography is a good choice – architectural subjects, for example. Rather than spending a great deal of time drawing the detailed façade of a building, it makes far more sense to take some photographs. In fact, I probably would not include very much detail in the final painting, but in order to capture a convincing impression of the building, it is essential to work from an accurate source of reference.

Having recorded the basic factual information about a subject with my camera, I can use my time more profitably by making notes and sketches. In these I concentrate on compiling reference material for the key qualities that I hope to develop in the painting later on – information about colour, light and the more transient, personal qualities that I am unable to capture with the camera.

I think the two most important points to remember about working from photographs are to use only your own photographs, and to avoid copying photographs. If you use your own photographs of a location, you can probably recall what it felt like to be there. With someone else's photographs, you will have no direct experience of the subject matter and therefore must rely completely on what you see in the photograph. However, photographic reference is full of potential hazards. For one thing, the colour quality is rarely accurate, and additionally photographs tend to give an exaggerated impression of scale and depth, as well as a distorted sense of perspective. Also, where a photograph is the only source of reference, there can be a temptation to copy detail, resulting in a painting that is fussy and overworked.

Working from photographs

For *Falling Water, Rome* (opposite) I worked from three photographs. The difficulty at the Trevi Fountain, as indeed at many tourist sites, is that it is a very busy, confined place and therefore not ideal for sketching. Add to this the sudden downpour of rain on the day of my visit, and photographs became a very necessary means of gathering information. They enabled me to choose a viewpoint that I could not possibly have sketched from for a long period of time. In fact, the only sheltered spot I could find, along with a great many other very damp people, was squashed between two columns, against the wall of the building opposite the fountain.

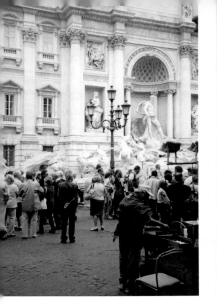
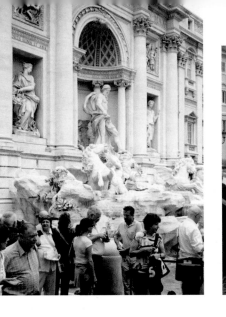
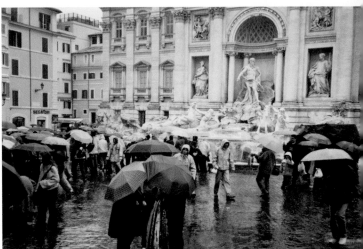

Above: Reference photographs for *Falling Water, Rome*. Because of the hustle and bustle at the Trevi Fountain, and the fact that it was raining heavily, I decided to rely on photographs as a source of reference.

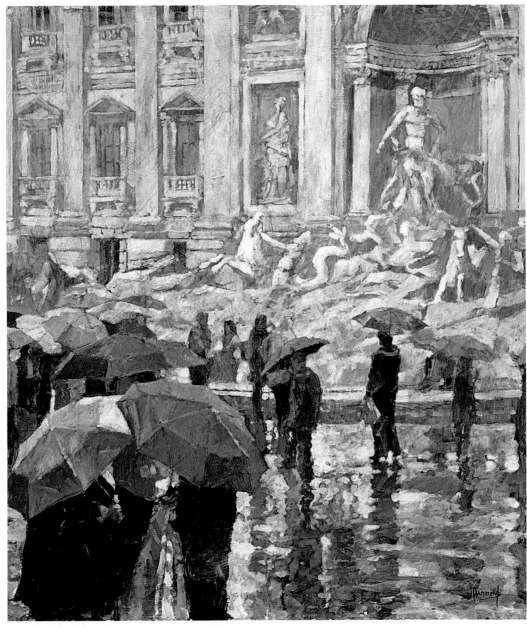

Falling Water, Rome
48 x 42 cm (19 x 16½ in)
For this painting, I worked from the three photographs shown above. If you do need photographs for reference, I would advise that you take a selection and work from them all. It makes it easier to resist the temptation to copy from a single photograph, which almost always results in a rather uninspired painting.

When photographs are an important source of reference, I always work from a selection of prints rather than just a single image. This is an approach that I would recommend, as it encourages you to select information and develop your own composition and content rather than slavishly copying from a single photograph. When I am working on a painting in the studio I often pin up a selection of photographs, together with the sketches, to help me relive the experience of the location, and this in turn helps me to paint with greater feeling and expression.

Plein-air painting

Given the right subject matter and conditions, there is no doubt that painting *en plein air* (in the open) can be extremely enjoyable and rewarding. Understandably, when we think of Sisley, Monet, Van Gogh and the many other great artists who have worked in this manner, there is a good deal of romance associated with *plein-air* painting and it does seem the ideal way of working. What could be better than being outside and painting

Dusk, Murano
27 x 30 cm (10½ x 12 in)
Painting on site, with its obvious time constraints, encourages a very direct, emotive approach, which I think adds to the success and quality of the final work.

Morning Shine
26 x 30 cm (10½ x 12 in)
This is another location
painting for which light was
the inspiration. Most of
the work was completed
within an hour, with just
a few finishing touches
added in the studio.

directly from the subject matter, totally involved in the sense of place? This must surely help you to paint with sensitivity and conviction!

Certainly it can, but it is never quite as easy as it sounds. As discussed on page 42, much depends on the reliability of the light, weather conditions and other practical considerations. For me, *plein-air* painting is essentially an extension of sketching; I regard it as the next step in compiling reference information. Often, these paintings are small and unfinished. They can be useful for exploring one aspect of the subject matter that I anticipate will be the key feature in the proposed studio painting. Or the intention might be to help gain a better understanding of the subject in general. When conditions are favourable I am sometimes tempted to work on a larger board, perhaps up to 40 × 45 cm (16 × 18 in) and, if things go well, this might result in a finished, or almost finished, painting. But always the principal aim is to experience an interaction with the subject matter rather than strive for a fully resolved image: see *Dusk, Murano* (opposite) and *Morning Shine* (above).

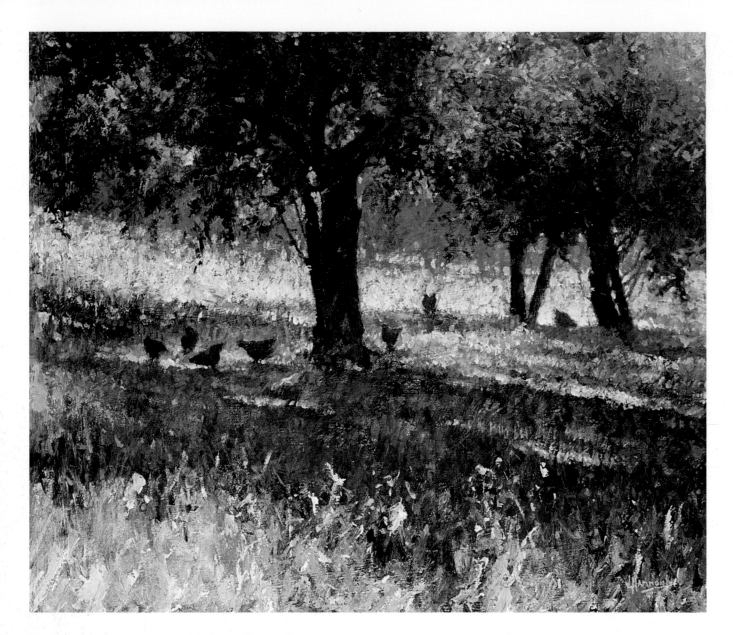

Beneath the Almonds
35 x 40 cm (13¾ x 15¾ in)
For this subject I felt that I
needed a colour study,
rather than written notes, to
record the colour
combinations adequately.
But very quickly the work
began to develop into a
finished painting.

(Opposite)
San Gimignano Rooftops II
40 x 34 cm (15¾ x 13½ in)
With a view such as this,
what could be better than
working on site, directly
from the subject matter?

Light and mood

Beneath the Almonds (above) is a good example of a painting that developed in the way described on page 53. I started with tonal sketches but then decided that a colour study in acrylics would also be helpful. With this subject there was a set of colours that was crucially important to capturing the mood of the scene successfully, and I did not feel confident that I could record the colour combinations adequately with only written notes. Moreover, this was a group of colours that was new to me. So I decided to investigate the colours further by testing them out in acrylics on a prepared board. Before I knew it, this began to develop into a fairly complete painting, which in fact I finished in the studio. *Plein-air* work is always like this; it is very much a matter of making decisions that will help you compile the exact reference material that you need.

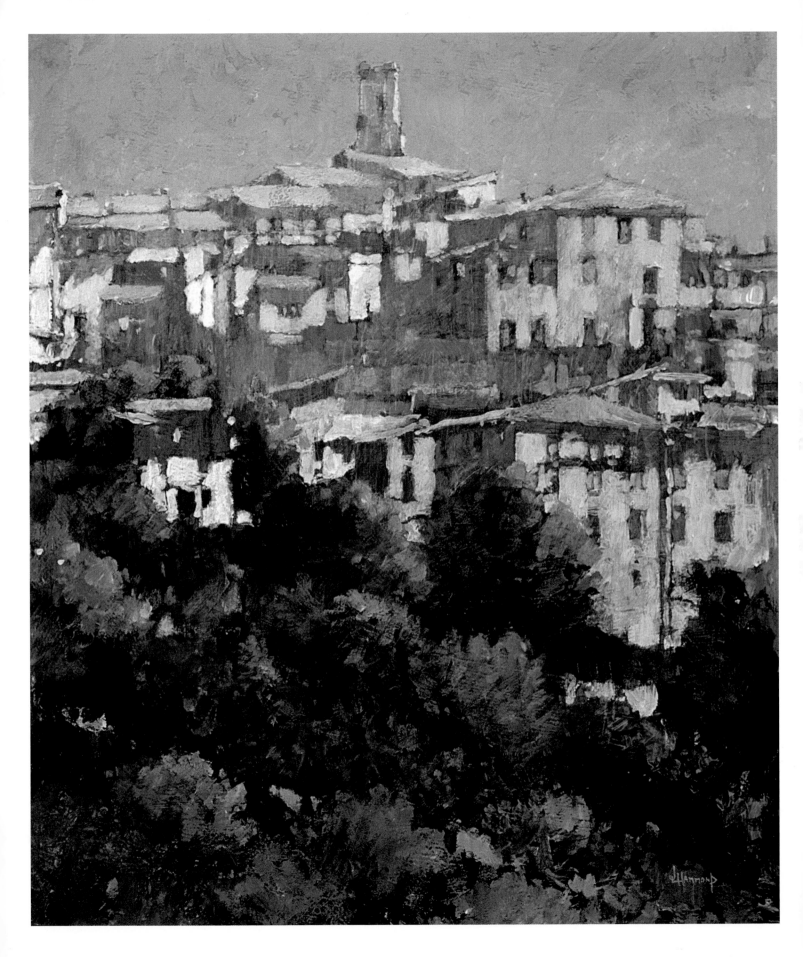

PICTURE PROFILE

Skaters, New York

This was quite a different type of subject matter for me, that I came across quite by chance on my first visit to New York in 2006. It was shortly before Thanksgiving and the city authorities had set up an ice-skating rink outside the Rockefeller Center. Kate and I had been touring the city during the day and we arrived at the Rockefeller Center late in the evening, at about 11.30pm. The rink was still full of families skating, and with the background music, the lights and so on, it created a very emotive scene. I instantly thought that it would make a good painting.

However, because of the nature of the subject and the time of day, a *plein-air* painting was obviously out of the question. So I took some photographs and used my pocket sketchbook to make a few notes about colours and movement, and did some little sketches of the skaters in different positions. I did not try to compose a painting at this stage; instead I just walked around the ice rink and jotted down as much information as I could to capture the special atmosphere of the place.

The advantage of this subject was that I knew I could revisit it the next evening. It would not be quite the same as my initial encounter, of course, but similar enough for me to observe more thoroughly the general setting and the architecture. All of this information proved useful when I returned home to my studio. The only difficulty was in creating a viewpoint that gave a convincing impression of the sense of space. In fact it was necessary to distort the space in order to make a composition that worked effectively. Here, the design of the painting had to complement the narrative. The subject reminded me very much of some of my beach paintings containing little groups of figures, each group individual in its own way and each with a story to tell.

Skaters, New York
72 x 61 cm (28½ x 24 in)

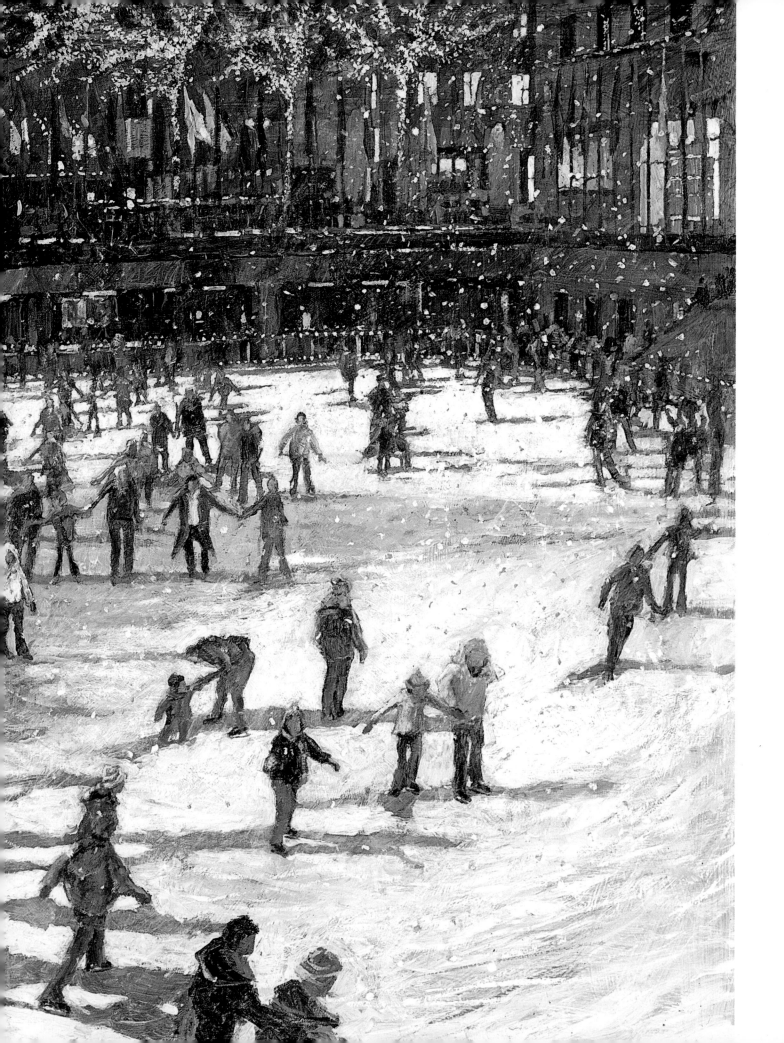

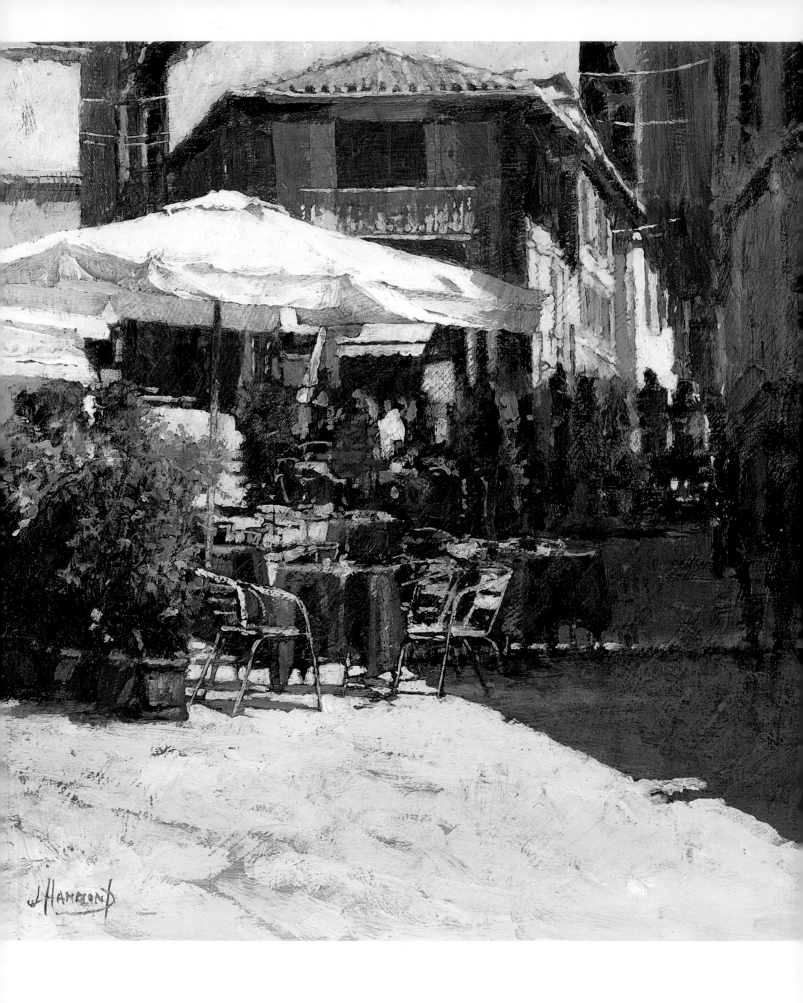

3 Design

The design of a painting is another aspect that has a strong influence on the ultimate success and impact of the work. When planning the design there are two main elements to consider. Obviously the first is the way that the shapes, tones and colours interact with each other, together with their general arrangement within the limits of the picture area. But equally, the part played by the actual surface of the painting is important – the look and feel of the paint and how this contributes to the way that we 'read' the content.

Sometimes there is a powerful sense of design inherent in the chosen subject and thus it is simply a matter of restating the existing shapes and colours in a personal way. At other times the subject matter demands a greater level of manipulation, exaggeration or editing in order to produce a cohesive design. And of course, in making decisions about the design, the most influential factor will be your response to the subject matter and working out how to convey the qualities that most impressed you. Ideally, the balance, contrasts and particular relationships of colours and shapes should contribute very positively to the way that you want to interpret a scene or express a certain idea.

In my view, for figurative paintings to succeed with the necessary degree of credibility and integrity, they must be founded on real experience, observation and fact rather than relying unduly on invention and imagination. This said, in my paintings I am principally interested in creating a particular environment, a sense of my individual response to the subject matter and what it was like to be there. To this end I feel free to select and emphasize as necessary, in order to convey the desired emotional impact. Absolute likeness is not essential. It is more important that the composition supports my intentions for the painting, although I am careful not to let it become obviously contrived.

Theory and intuition

A good composition will enhance the mood and character of a work, and indeed in some subjects it might well prove the best means of adding a striking sense of drama. Additionally, its purpose is to encourage the viewer to follow a certain route around the painting, usually such that the eye eventually rests on a specific point of interest. But the design should never feel imposed or very noticeable; viewers should be unaware that their response is being influenced by a particular arrangement of shapes and colours.

There are various conventions and devices that can help in creating a successful composition, although it is best not to apply these too readily, otherwise the results can look contrived. However, it is always worth knowing about design principles and proportions. In fact, what usually happens is that, with experience, any reference to such concerns becomes intuitive rather than deliberate. Certainly I never feel governed by 'rules' and accepted practices in my approach to composition – instead I tend to rely on my assessment of what looks and feels right.

Some artists start by dividing the canvas into thirds or by using diagonals or some other type of division, and then build their composition from that basis. This no doubt guarantees the painting a sound structure, but I think it could limit the expressive power and individuality of the work. I prefer a less formal approach. I like to try something in one position and then, if necessary, move or adjust it until I am satisfied that everything is

A Shaded Corner,
Perugia
30 x 30 cm (12 x 12 in)

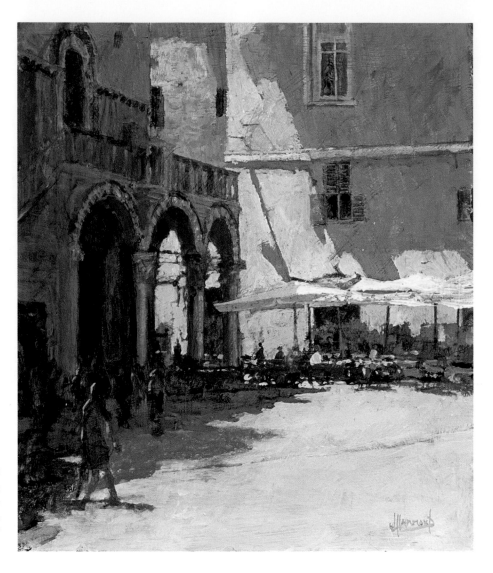

working as a coherent design. This allows for greater freedom and personality in the design format. So, my advice is to keep the 'rules' and conventions in mind, but try not to let them dominate your design ideas.

The rule of thirds

A design format that is always effective, and which has been popular with artists since Renaissance times, is a division of the picture area into thirds. In a landscape, for instance, the three divisions might correspond with foreground, middle ground and background areas. More often, however, artists like to place a key feature of the composition, perhaps a figure, a tree or the edge of a building, at a point about one-third or two-thirds across the painting. Such a division, and the consequent relationship between the one part (one-third) and the remaining area, works equally well whether applied in a horizontal or vertical direction.

This principle, sometimes known as the rule of thirds, is based on the Golden Section (or Golden Mean), a proportion that is found in nature and which is generally accepted to create an aesthetically pleasing arrangement. The ratio or proportion in the Golden Section is approximately 5:8, but as explained, most artists think of it in terms of thirds. I tend to be more conscious of this sort of division when there is an obvious horizontal division to place within a subject, as in *Portico, Church of the Angels, Assisi* (opposite). Notice that in this painting the far edge of the floor and the figures are positioned about

one-third of the way down the picture area. Similarly, in *The Old Oak* (page 62), the position of the tree divides the painting into a ratio of one-third to two-thirds, while the area of shadow at the bottom repeats and balances this division in the opposite direction.

Again, I would stress that for me such clearly planned compositions are the exception rather than the rule. For these paintings, I started with some rough brushmarks to indicate the basic structure – the position of the horizontals and verticals and the key lines in the foreground area in *Portico, Church of the Angels, Assisi*, for example. I felt that in this painting, as in *The Old Oak*, the division of the picture surface was such a vital element that it had to be decided early on. This is not something that I normally do: usually the composition develops more organically; is more instinctive than formulaic.

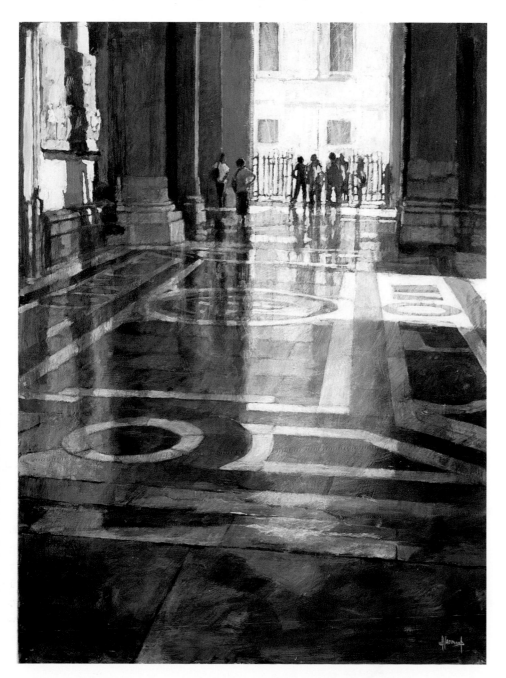

Portico, Church of the Angels, Assisi
60 x 45 cm (23½ x 17½ in)
I rarely start with a preconceived idea about a composition, except perhaps in a subject like this, in which there is an obvious horizontal division. Here, I decided to place that division to correspond roughly with the Golden Section proportion – about one-third of the way down the picture area.

The Old Oak
50 x 60 cm (19¾ x 23½ in)
Here again, I felt that the
division of the picture
surface, and particularly the
position of the tree, was
such a vital element that it
had to be decided early on.

Challenging conventions

Once you have gained sufficient confidence and experience, it can be very rewarding to experiment with some less conventional approaches to design. For example, as well as using the traditional rectangular shape format, I also enjoy painting square-shaped compositions, as in *Vineyards Near San Gimignano* (opposite). With a square board I am encouraged to be more inventive, as I find that compositions based on principles such as the Golden Section work less well with this shape. Instead, I often use a design based on an 'X', 'Z' or 'W' shape to create a flow of interest throughout the painting.

In *Vineyards Near San Gimignano* there is a kind of zigzag movement leading towards the distant hill town; notice too that this design breaks with another convention by placing the foreground track right in the middle of the painting. We are taught to avoid divisions of this type, as they tend to create a rather symmetrical and perhaps therefore less interesting effect within the painting. But (as here) it is the overall impact that counts, and a balanced effect in one area can be offset by other shapes and features elsewhere.

A good composition will involve contrast so that, for example, the excitement of colour or degree of interest within the content is not distributed evenly throughout the painting. There should be areas in which to rest the eye as well as areas of activity. But there are no set rules of course, and equally other factors, such as colour and texture, can contribute very positively to the overall visual impact. An unusual or challenging sense of design might well be the quality that initially attracts you to a subject and inspires you to paint it. Or, you may wish to add drama to a painting and draw attention to it by designing it in a certain way.

Many paintings seem to apply design conventions and at the same time disregard them. For instance, in *Covent Garden for Coffee* (opposite), there is a strong horizontal

Vineyards Near San Gimignano
80 x 80 cm (31½ x 31½ in)
For this subject, I decided to use a very high horizon to manipulate the composition and accentuate the rolling fields.

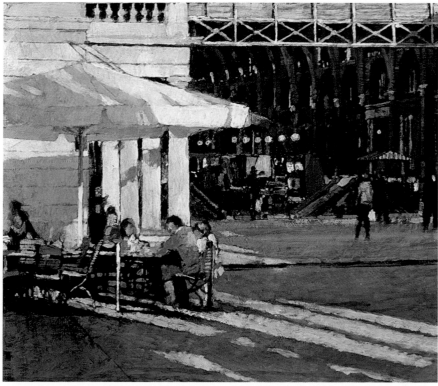

Covent Garden for Coffee
40 x 45 cm (15¾ x 17½ in)
At first glance, this seems a rather one-sided composition, with all the interest on the left. However, the shafts of light through the foreground and across the top bring the design into balance.

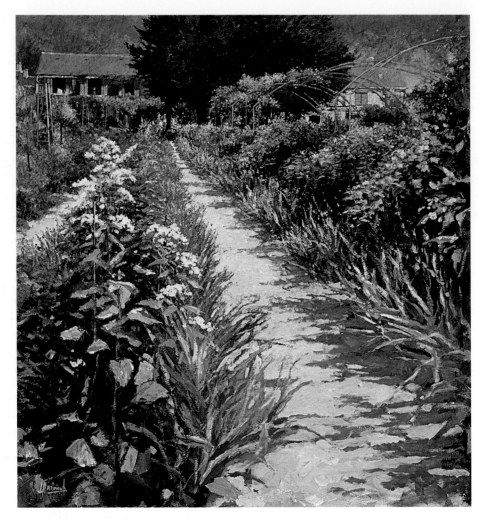

line placed almost dead centre, but this is counteracted by the various vertical elements on the left and also by the diagonal shafts of light below. *Fragrant Path, Giverny* (above) was also a challenging design to tackle, mainly because of the dramatic directional movement, almost to a vanishing point. Here, the horizon line has been pushed right up to the top of the painting to create a powerful sense of space. But there is no sky area, and obviously that added to the difficulty of suggesting space: it has to be achieved through tone, colour and paint-handling techniques rather than with the help of an obvious skyline and light source.

Essential elements

The success of a composition relies on decisions relating to a number of elements, of which balance, pattern and scale are among the most important. Balance obviously concerns the division of the picture area – the relationship of big shapes to small shapes and so on – and it must also consider contrasts of tone and colour and the part these play in adding interest and meaning to the work. Pattern is a way of adding rhythm and movement to the design and directing the eye around the painting, while scale is often a more difficult element to judge. It is a matter of deciding on the actual size of the painting as well as the relative scale and importance of individual features within it.

There are some subjects that instinctively suggest a large painting. See *The Yellow Balloon, Sunday, Rome* (opposite, top), for example. Inevitably it is the subject matter that most influences the size of the painting and in fact the design considerations for small and large works are quite different. I know this from my own experience, when trying another

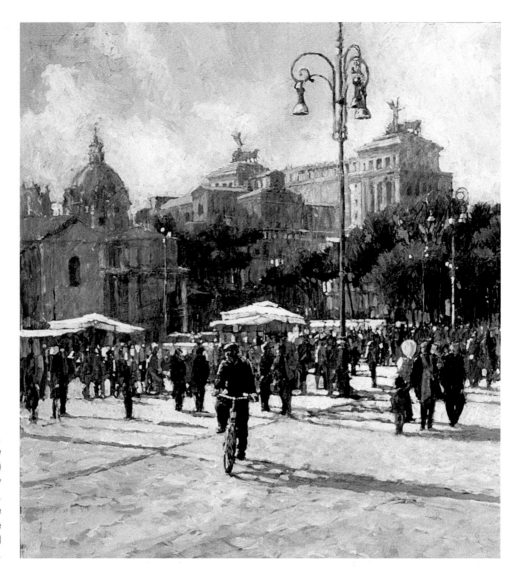

*The Yellow Balloon,
Sunday, Rome*
90 x 80 cm (35½ x 31½ in)
This road is normally very
busy with traffic; fortuitously,
I just happened to be
there on one of the
Sundays when the road
is closed to vehicles.

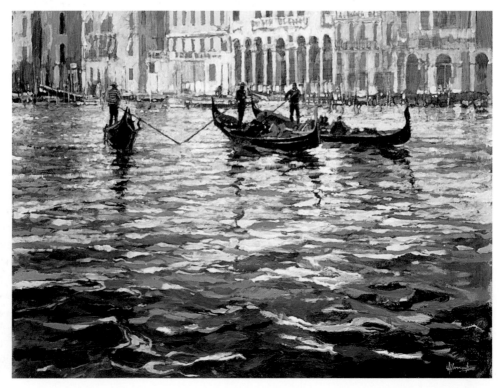

*Across the Canal,
Flooded with Light*
55 x 70 cm (21½ x 27½ in)
I think every painting should
be a challenge in some way,
and here the challenge was
to capture the wonderful
quality of light, particularly
on the surface of the water.

version of a painting in which I have altered the scale. Essentially, a small painting can be quite complex in design, because the area is confined and thus the viewer's attention is similarly restricted – it is not easy to get 'lost'. However, in a large painting there is more scope for the viewer to wander aimlessly, and so a fairly simple composition is usually the most effective in producing a cohesive result and enabling the work to be fully appreciated.

Shape

Shapes are the building blocks of composition, just as they are of drawing. In my initial assessment of a subject, in order to translate what is often quite a complex scene into a painting, the first step is always to consider its fundamental structure in terms of the main shapes. From this assessment of the important shapes and spaces I can make a drawing, and subsequently my understanding of the structure of the subject will help me to develop a convincing composition.

The simpler the composition, the greater the emphasis on the shapes contained within it. The way that these divide the picture area, together with the contrasts in the outline and form of the shapes and their relative sizes, are all vital factors in achieving a sound composition, as in *Flight of Light* (below).

The horizon in this painting divides the surface more or less in line with the Golden Section proportion, and there are only four main shapes: the sky, the headland, and the two interlocking wedge-shapes that make up the large sea area in the foreground. The headland itself is a very weighty element to have in the top part of the painting, but it is balanced by the tonal intensity beneath. Further interest and movement is created with the ribbon of birds and the rippling highlights in the water. Additionally, these contribute, as with other aspects, to directing our attention to a discreet focal point – the backlit archway at the tip of the headland.

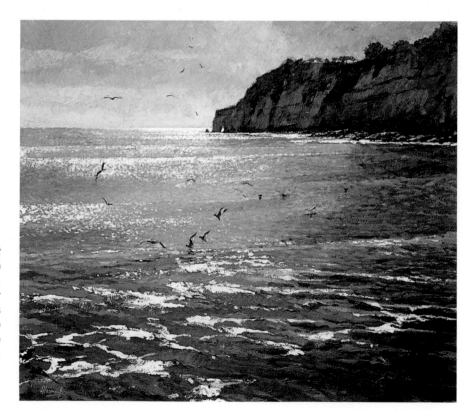

Flight of Light
61 x 70 cm (24 x 27½ in)
With a simple composition, there is always a greater emphasis on the shapes contained within it and the way that these divide the picture area, as here.

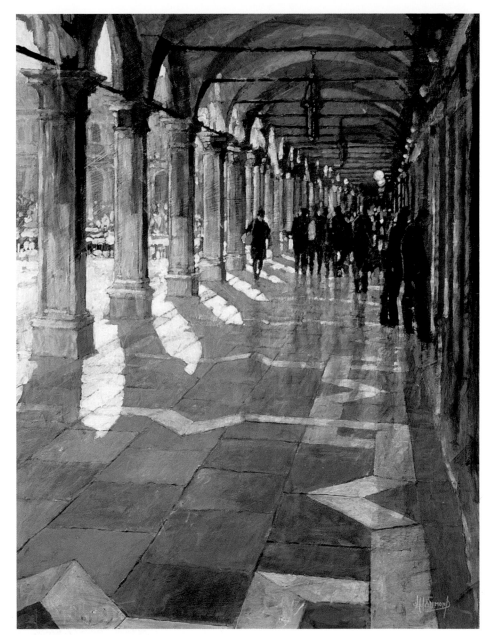

Quadris for Coffee
61 x 46 cm (24 x 18 in)
This composition is very
much based on pattern and
repeated shapes – the
pattern of the marble floor,
for example, and the
repeated shapes within
the colonnade.

Rhythm and movement

I often instil a feeling of movement throughout a composition by introducing little touches
of the same colour to link the various parts and so create a flow of attention from one
area to the next. The colour is either overlaid or left showing through from the initial
underpainting. There might be three main sections to a painting, for example, and there is
always the challenge of how to join these visually and establish a sense of harmony. Using
subtle accents of colour here and there, or devising some kind of pictorial linking element,
such as the birds in *Flight of Light* (opposite), are good methods to consider.

Sometimes too, the aim is to imply some kind of physical movement within subject
matter – perhaps flowing water, for example, or figures walking across a piazza. How can
you achieve such an effect simply by using different brushmarks? I would say it relies on
the considered application of two aspects: brushmarks of the right shape and emphasis;
and where you place those marks and the relationship between them. There needs to be
some sense of energy and flow in the brushmarks themselves, combined with changes of
scale, character and so on.

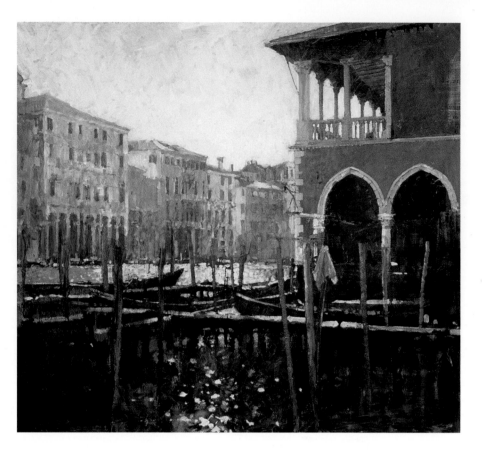

Other directional lines, shadows and features within the painting may also help. Look at
The Yellow Balloon, Sunday, Rome (page 65), for example, in which the figure on the bicycle
is a key element. He is heading straight towards us and forms a sort of arrowhead moving
forward from the figures behind. This, together with the contrasts in grouping, scale, colour
and definition of the figures, creates a very convincing mood of bustle and activity.

Colour and design

Colour is inevitably an important influence in relation to the other decisions that you
make regarding composition. For instance, a shape could be emphasized or, at the other
extreme, reduced in impact, according to the choice of colour and its method of
application. As in *From the Fish Market, Venice* (above), in which the striking colour of
the awnings creates a strong focal area and defines the two arches more emphatically,
colour is always a key element in the design. Indeed, it can be the dominant force.

In contrast to *From the Fish Market, Venice*, look at *Footsteps, Oude Kerk* (opposite),
which is essentially a tonal painting. Here, the low-key colours not only contribute to the
flow of the design as the composition leads the eye back into the far distance, but equally
they enhance the feeling of tranquillity in that space.

In *Umbrian Poppies* (opposite) on the other hand, colour is a very decisive element in
creating the main shapes of the composition. Essentially this is a painting of two parts –
the colourful foreground area and the view beyond. In design terms, the impact of the two
parts is softened by the fact that they join at a diagonal line rather than at a harsh horizontal
one, and also, of course, they are linked by the vertical line of the tree on the left.

Relative values

The use of colour to carry the eye from one part of a composition to another can also
apply on a grander scale when, for instance, there is a need to highlight or 'frame' areas of
interest or create a much more obvious linking device. *Early Morning Shadow, London*

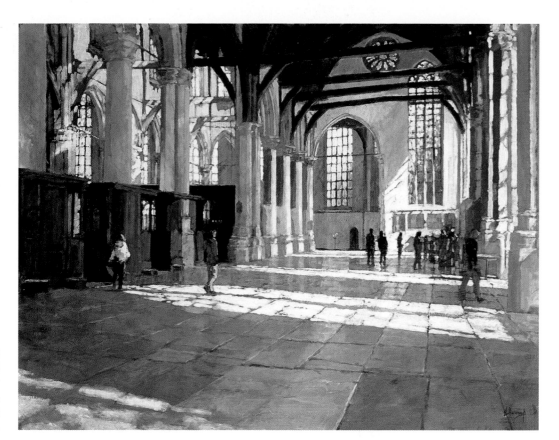

Footsteps, Oude Kerk
61 x 80 cm (24 x 31½ in)
I felt that a low-key colour palette would suit the quiet, contemplative mood of this atmospheric subject.

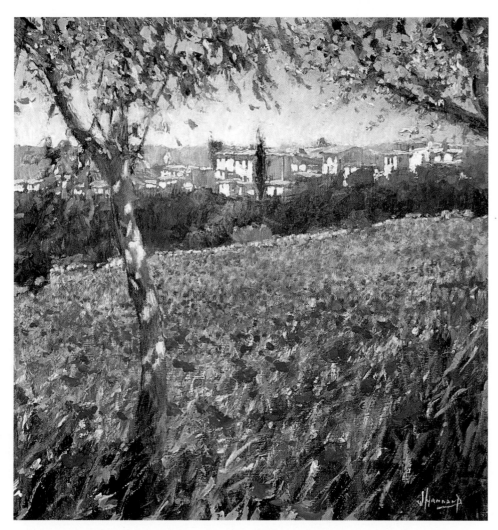

Umbrian Poppies
32 x 31 cm (12½ x 12¼ in)
As here, colour itself can be the quality that inspires a painting.

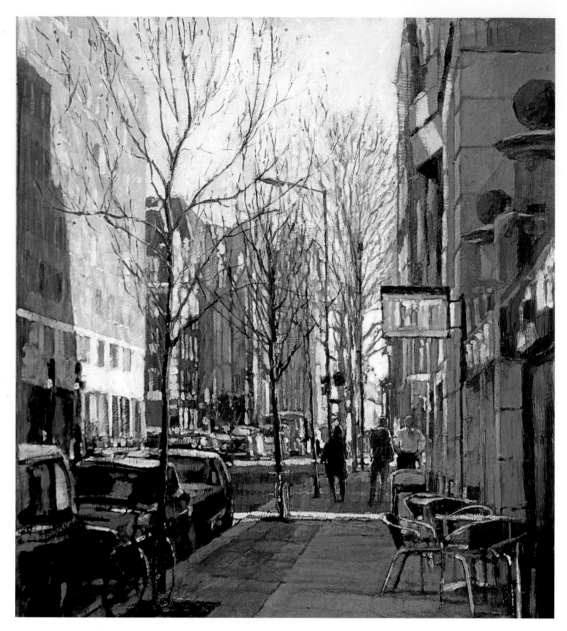

Stirs (above) demonstrates this point. I liked the contrast between the foreground area of shadow and the sunlit buildings further back and so I decided to make the most of the shadow colour to emphasize that effect and indeed link the whole composition together. Similarly, in *A Quiet Spot, Trastevere* (opposite), there is a large area of shadow that flows through the painting and links areas together. I often use shadows in this way and I normally develop such effects with a sequence of glazes (see page 83).

Additionally, remember that exploiting relative colour values is often a good technique for conveying the idea of space and depth in a painting. In general, warm colours stand out and come forward – and are therefore useful in the foreground – whereas cool colours tend to recede and so can be used to create a sense of depth. This is clearly true in paintings such as *Umbrian Poppies* (page 69), although in fact I find that the opposite effect can work just as well! Look at *Softly Lowing* (opposite), for example. Here, the principal areas of interest are the middle ground and background, and consequently these involve the stronger colour treatment. However, because there is due consideration given to the relative tonal values, there is no loss of depth in the painting.

A Quiet Spot, Trastevere
30 x 35 cm (12 x 13¾ in)
The shadows in this painting
proved an extremely effective
means of linking areas together
and thus unifying the design.

Softly Lowing
42 x 50 cm (16½ x 19¾ in)
Often, as here, I use the
foreground as a space to lead
the eye into the painting, with
the principal areas of interest
further back.

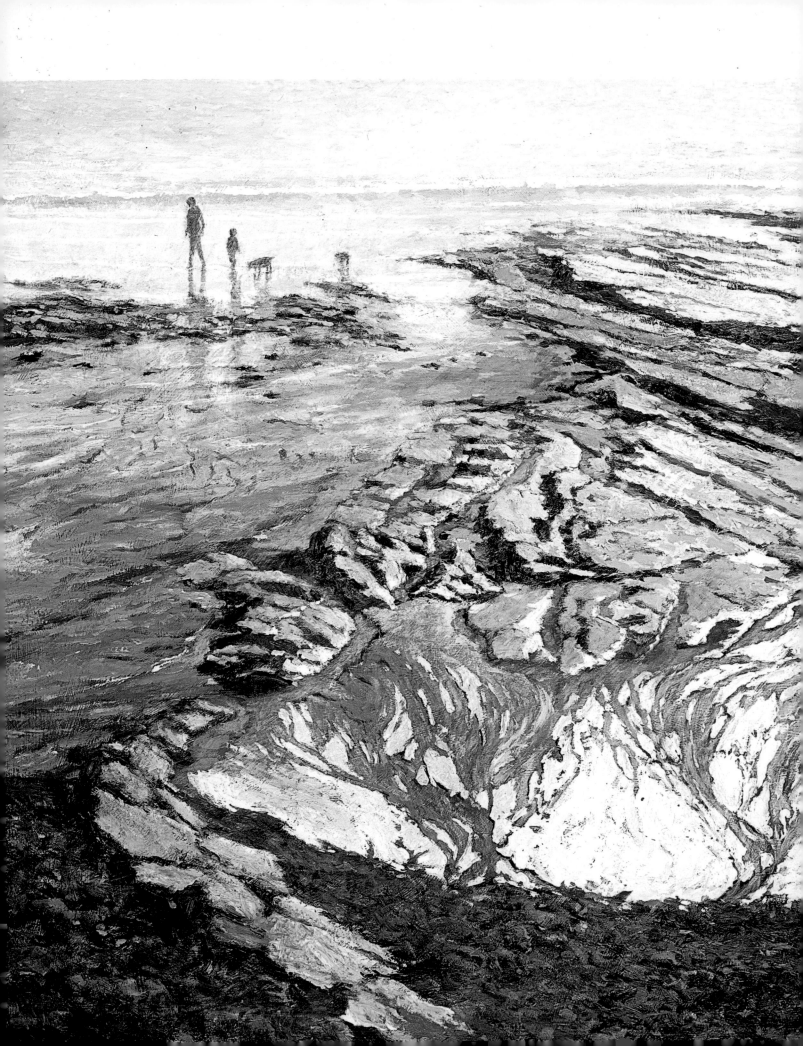

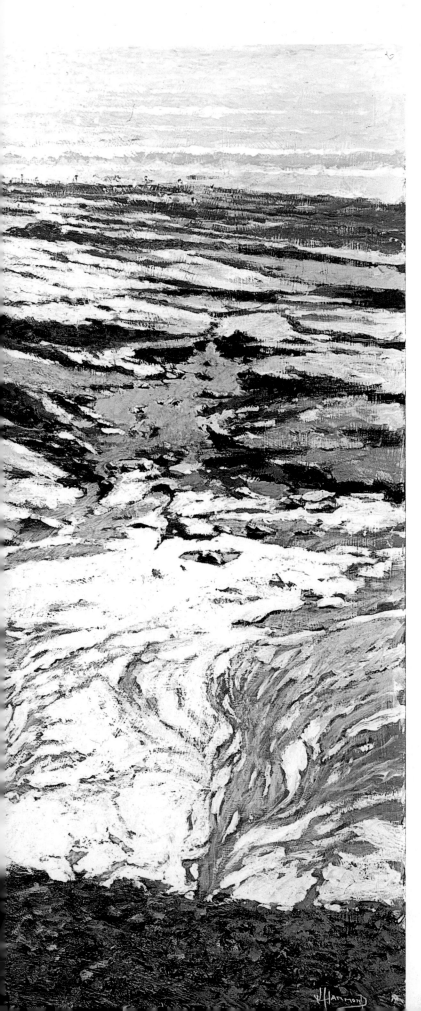

PICTURE PROFILE

Spring Tide, Sidmouth
Being a wonderfully open, impressive vista, I felt that this subject should be painted on a big scale. Consequently it is a studio painting worked from reference material, including sketches of the figures, made on location. What I particularly liked about the subject were the rhythms and patterns in the rock formations. In order to make the most of these and express them effectively, I decided to lift the horizon and focus on a large foreground area. From a design standpoint, the painting is constructed from a series of interlocking shapes, with a flowing, zigzag movement that leads to the focal point – the two figures and their dogs playing on the shoreline.

The colour palette is essentially based on contrasting complementary colours, between the blues of the sea and the orange/browns of the rocks. This relationship of colours helps to emphasize the shapes in the foreground, and interestingly this results in a fairly abstract area. In fact, it is principally the figures that define the mood, sense of place and scale of the scene – a scene that so impressed me that I painted several versions of it, experimenting with different forms of composition.

Spring Tide, Sidmouth
80 x 90 cm (31½ x 35½ in)

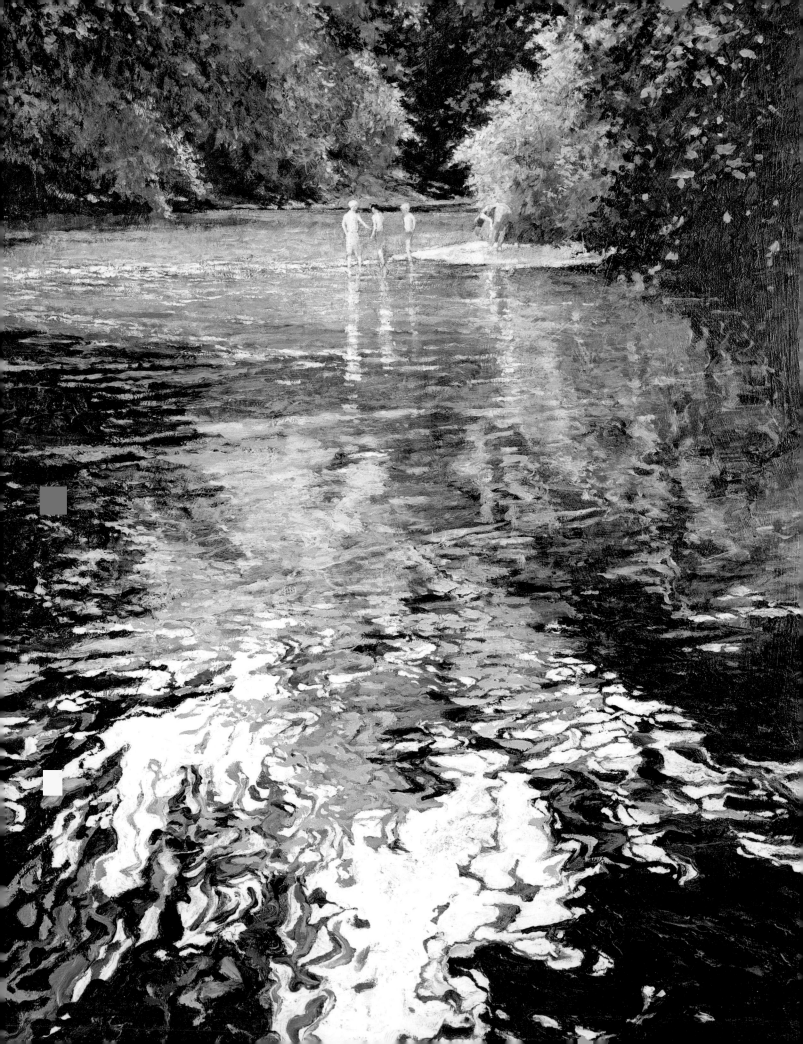

4 Painterly Qualities

One factor that always contributes to the expression of an idea in a sensitive, personal manner is an awareness of the physical properties of paint – its look and feel, and the way that it can be applied and manipulated on the board or canvas surface. Such qualities are among the most influential features in creating impact and determining a response from those who view the work.

The particular texture of a brushmark or the vibrancy of a colour can be extremely telling, and each plays its part in helping to convey a certain mood or effect. This is probably most evident in abstract painting, but equally it is often a consideration in figurative work. Naturally, the marks and colours should relate to the subject matter and the sort of impact you have in mind, and invariably the painting process will require a certain amount of selection and exaggeration.

Another point to note, of course, is that painterly qualities cannot be considered in isolation. The way they are used must, in turn, relate to the fundamentals of constructing a painting, as discussed in chapters 1 to 3. In my comments on the paintings chosen for analysis at the end of each chapter, I hope it is evident that painting normally involves both deliberate and instinctive actions as well as both practical and intellectual processes. Artists soon learn that each decision must relate not just to a particular part or aspect of the work, but to the development of the painting as a whole.

Painterly qualities are always a key element in the way that I interpret the various subjects that attract and excite me. *Sunlit Shallows* (page 76) is a typical example. This painting is predominantly about the water – its reflections and the way it has been influenced by a certain type of light. Note how the surface quality of the water is handled, so that the paint itself infers a sense of depth and translucency, while in contrast the overhanging trees have quite a different texture and character.

Colour

Colour, especially strong colour, is one of the first things we notice and react to when viewing a painting. In fact, the initial impact of colour is often independent of the subject matter, and again this is something that is particularly true in abstract paintings. If a canvas includes a big splash of red, for instance, this will instantly attract our attention, with our interest aroused by the colour itself, before we attempt to assess what it might mean.

There are some colours that elicit an almost predictable response because, through both instinct and conditioning, we have grown to associate them with certain properties or characteristics. For example, red traditionally stands for danger, while green is associated with nature and is perceived to be a more peaceful and relaxing colour. In Renaissance paintings, the robes of the Madonna were painted blue, because blue was a rare and expensive pigment and thus was used to denote power and significance. Although colour associations such as these may not directly influence our reaction to a painting, they are nevertheless a factor. So, preconceptions about colour are something that artists cannot totally ignore when deciding which colours to use and where to place them.

Playing on the Sandbar
80 x 60 cm (31½ x 23½ in)

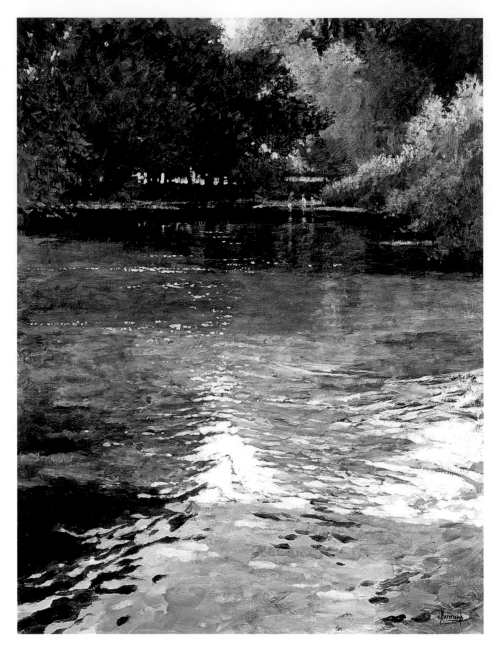

Normally, when we first start painting, we work from observation and our use of colour is descriptive – we paint what we see. This is the best way to gain a knowledge and understanding of colour. However, we gradually begin to respond in a more personal, emotional way to the subject matter and naturally this is reflected in our use of colour. We no longer rely on expressing everything exactly as we see it; rather we begin to select, edit and emphasize, so that the painting communicates more faithfully the qualities which, for us, are the most exciting and important in the subject matter. Colour is a key element in this process and, with experience, we find a way of balancing both the descriptive and subjective approaches.

Colour key

'Key' is one of those terms that means different things to different artists. Generally speaking, it refers to the overall impression of colour and tonal values in a painting. Thus, a high-key painting is one in which there are predominantly bright colours and light tones, while a low-key painting has dark, subdued colours and tones.

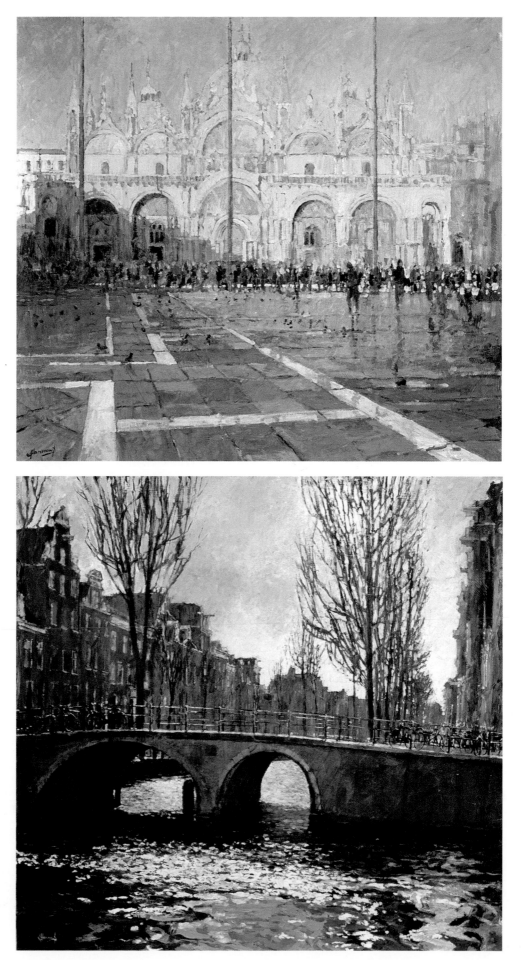

*Golden Façade,
After the Rain*
61 x 65 cm (24 x 25½ in)
Here, the blocks of
complementary colours help
to enhance the effect of the
light reflected by the
magnificent buildings.

Amsterdam Winter Light
61 x 62 cm (24 x 24½ in)
The aim, in this painting,
was to capture the feeling of
cold sunlight and essentially
this is achieved by severely
limiting the colour range.

However, for me, colour key is more specifically to do with the level of colour contrast in a painting. In a high-key painting I would expect to find complementary colours and other colours used in bold juxtapositions to create a powerful visual statement, whereas in my view a low-key painting is essentially about colour harmony.

A Quiet Moment (below) is an example of a low-key painting. Having noticed the woman sitting under the sunshade, calmly sketching and seemingly oblivious to other parts of the beach, which were noisy and crowded, I was inspired to make a painting that reflected the sense of peace and tranquillity that she evoked. Consequently, I kept to a limited range of harmonious colours and deliberately edited out or played down any strong accents of colour, such as the flash of a red shirt or a brightly coloured parasol. These would have undermined the effect I wanted.

The Pescheria, Venice (opposite), on the other hand, includes the use of complementary colours or 'opposites' (colours that are found opposite each other on the colour wheel), in this case reds and greens. This creates an intense level of colour contrast

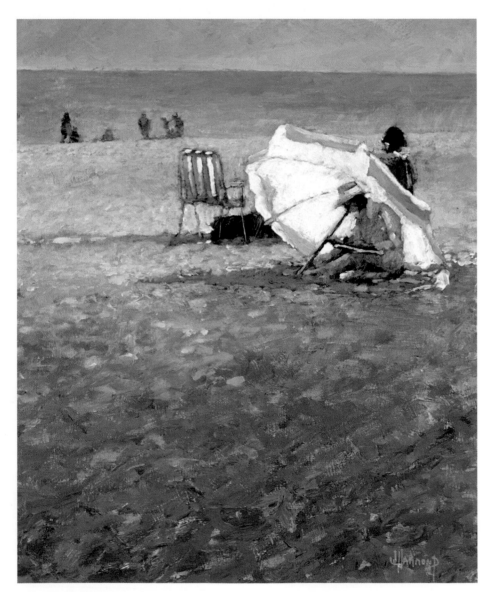

A Quiet Moment
30 x 25 cm (12 x 10 in)
Once again, I have kept to a limited range of harmonious colours to help express the quiet mood of this scene.

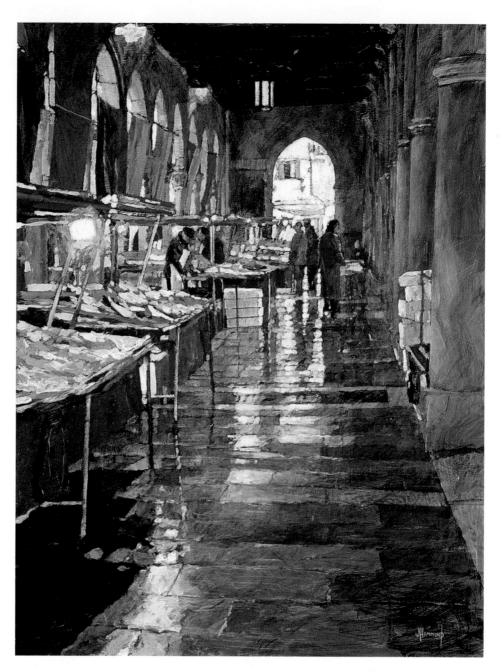

The Pescheria, Venice
61 x 46 cm (24 x 18 in)
With its obvious celebration
of colour, it is not surprising
that so many artists find this
subject such a joy to paint.

and thus what I would describe as a high-key painting. With its intriguing qualities of light – artificial, natural, and light influenced by colour – and the obvious celebration of colour, it is not surprising that so many artists find this subject irresistible.

Colour in action

The fact that I might choose a low-key or high-key approach appears to suggest that I deliberately limit the colours available for each painting. However, this is not the case. Before I start a painting, I naturally consider the general mood and emphasis of colour that I think will work best. But I find the idea of selecting and working within a specific range of colours rather artificial and limiting.

So, whatever the subject and approach I have in mind, I always begin with the same set of colours on my palette. This gives me the freedom to respond to developments in the painting as they occur, and while I may not intend using a certain colour, I may nevertheless require just a touch of it to help create a particular colour mix.

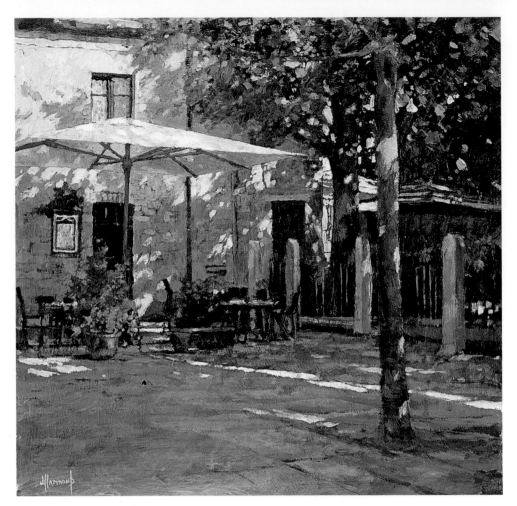

Cool Shade
40 x 40 cm (15¾ x 15¾ in)
I always look for colour in
shadows. For example, in
this Mediterranean subject
there are some lovely blue
tones in the shadows,
which are important for
helping to capture the mood
of the scene.

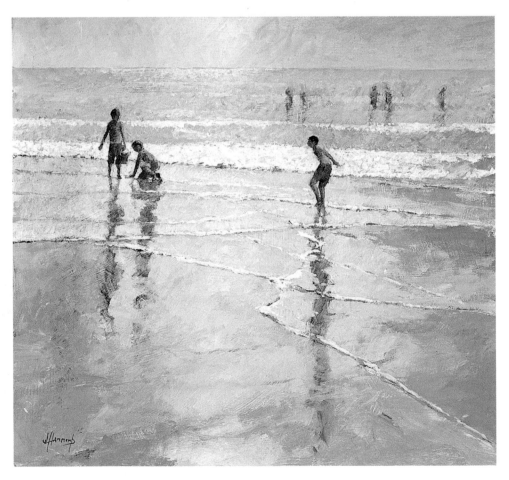

Shoreline Figures
42 x 45 cm (16½ x 17½ in)
The delicate expression of
colour in this work clearly
demonstrates how acrylics
can be used just as
sensitively as any other
painting medium.

Like many professional artists I use a palette based on two reds, two blues, two yellows (the primary colours), plus a couple of earth colours and white. The actual colours I use are titanium white, cadmium yellow light, cadmium yellow medium, cadmium red light, cadmium red medium, yellow oxide, Van Dyke red hue, light blue violet, dioxazine purple, cerulean blue, and phthalo blue. I place them on my palette (which is a white plastic tray) in that sequence.

The point about having all these colours available, if only for colour mixes, is demonstrated in *A Quiet Moment* (page 78). Remember, this is a low-key painting, so you would not expect to see red included anywhere. In fact, there is no obvious use of red, but in a more subtle way it does feature in many of the colour mixes, particularly those used for the foreground area.

Colour and interpretation

Sometimes it is the overall sense of colour that is the inspiration and reason for making a painting, as much as it is striking subject matter or composition, although these aspects are always important. *Ultramarine, from Benodet* (below) is a good example. With the intensity of the blue, the shimmering reflected light, and the splash of red on the distant sail, it was one of those sights that just had to be painted.

As I have mentioned, with experience our use of colour becomes more instinctive. There is less need to analyse the choice of colours: we are much more aware of the implications of using different colours and the reactions they will provoke. For me,

Ultramarine, from Benodet
60 x 80 cm (23½ x 31½ in)
Colour was the inspiration here. I could not resist the challenge of trying to capture those shimmering blues, which were made all the more exciting by the distant splash of red.

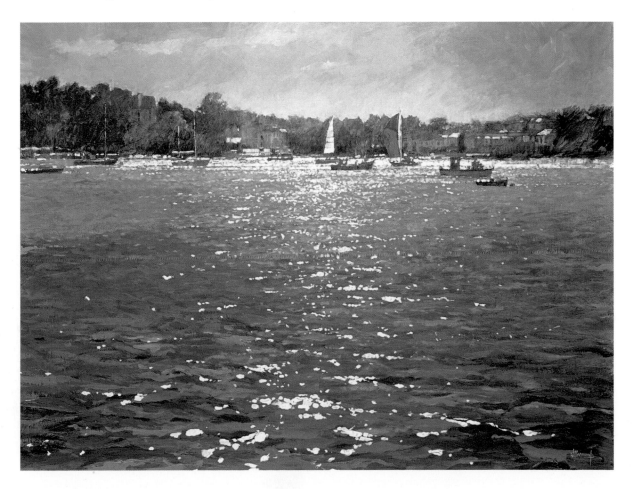

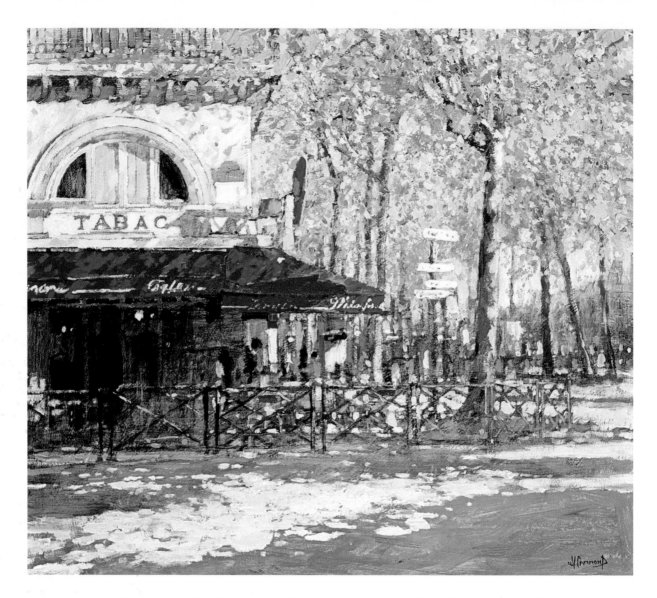

colour cannot be disassociated from a particular quality of light. Essentially it is the connection between colour and light, and the way that this is interpreted, that produces a certain mood and atmosphere in a painting. Thus, my first considerations when looking at the subject matter are the quality of light and the principal colour necessary to interpret the light. That colour will inform all my colour mixes throughout the painting.

The physical properties of colour and the way that a certain impact can be achieved by the thoughtful placing and relationship of colours is similarly demonstrated in *A Paris Corner* (above). Here, the three most dominant colours are the red of the café awning, the lime green of the trees, and the lavender/purple colours of the shadows. The interaction of these three main colours creates an optical vibrancy that perfectly expresses the feeling of extremely bright, dappled light, which I felt was the intrinsic quality of the scene at that particular moment in time.

Translucency and opacity

As well as its actual colour value (whether it is a particular type of blue, green, orange or whatever) each colour has other properties that can be exploited in a painting, most notably its degree of opacity or transparency/translucency. Opaque colours are dense and totally block out whatever colour is underneath, whereas transparent colours never completely conceal the underpainting. This is because opaque colours reflect rather than

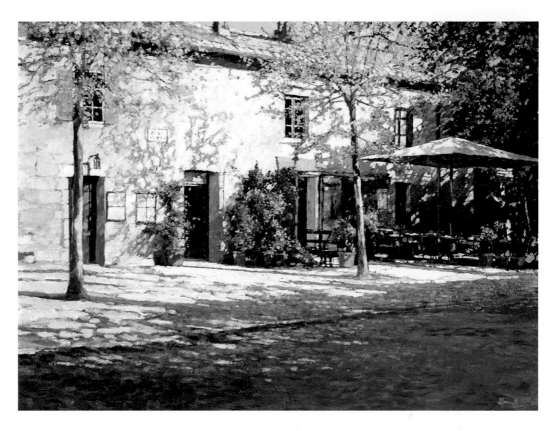

transmit light, while transparent colours allow light to pass through the various layers of paint and thus create a translucent quality.

In acrylics, transparent colours include burnt sienna, burnt umber, olive green, alizarin crimson, phthalo blue, raw sienna, raw umber and ultramarine blue, while colours such as cadmium yellow, cadmium orange, cerulean blue and emerald green are opaque. However, during the process of painting you can influence the opacity or transparency of a colour by adding different acrylic mediums to the paint, or through the way that you mix colours. For example, adding glazing medium will increase the transparency of a colour, whereas adding white will make it more opaque. If you mix a transparent colour with an opaque colour, the resultant colour will be opaque. Choose a high-viscosity glaze medium if you want to increase the transparency but at the same time use paint that is reasonably thick in consistency.

I never dilute acrylic paint with water. Generally I work with high-viscosity paint, using the colours in their natural thick, buttery consistency, straight from the tube. If I want to thin a colour, I add glazing medium. In my experience, adding water tends to turn the colour 'chalky'. Also, if you add too much water there is a danger that it will dilute the binder and consequently affect paint adhesion.

Working with glazes and impasto

Glazing can be a useful technique at any stage in a painting. I generally use it on the underpainting – the translucency allows me to block in and begin to build up the main areas of the composition without losing any drawing I have made. I regard it as an essential technique for creating different light effects, adjusting passages of colour (making them weaker, so that they are less dominant, or intensifying or harmonizing them), and producing effective and interesting darks.

A glaze is a thin film of transparent paint. To make a glaze, I dilute a colour with gloss glazing medium. You can also buy matt glazing medium, but I find that the gloss version creates colours that have a greater purity and transparency. If I need to make the glaze

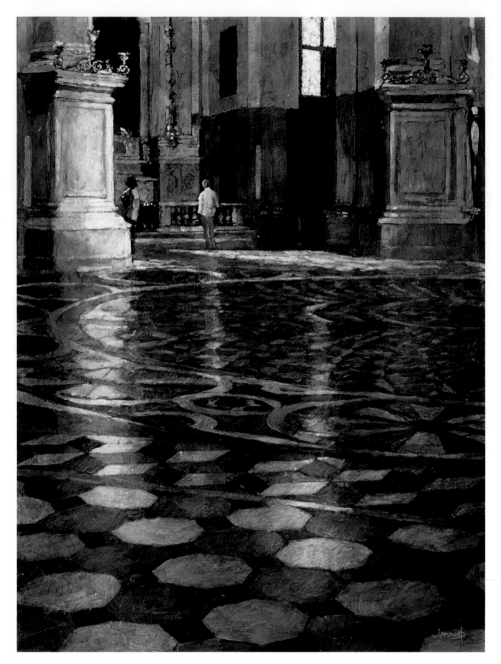

Falling Light, Santa Maria della Salute
61 x 46 cm (24 x 18 in)
Glazing is the perfect technique for developing surface effects such as this beautiful marble floor, which impressed me as much with its sense of history as its stunning visual qualities.

colours lighter, I add more gloss glazing medium. I seldom use white to lighten a glaze because this makes the colour opaque. The great advantage of glazing is that it offers a good degree of control in building up depth of colour and the particular painterly effects that you want.

In *Falling Light, Santa Maria della Salute* (above), I have used glazes quite extensively, especially for the marble floor area in the foreground. My aim here was to capture something of the particular surface quality of the floor and its sense of history, as well as the shadows and reflections. The best approach, I felt, was to work with various colour glazes, developing the effect slowly, layer over layer.

Glazes produce a physical quality in that their transparency allows light to travel through the different layers and reflect back. In so doing, the light picks up all the various colours and creates a sort of optical colour mix. This is the effect I wanted to achieve to capture the beauty of this 17th-century marble floor, for which I estimate I used a sequence of over 30 different glazes.

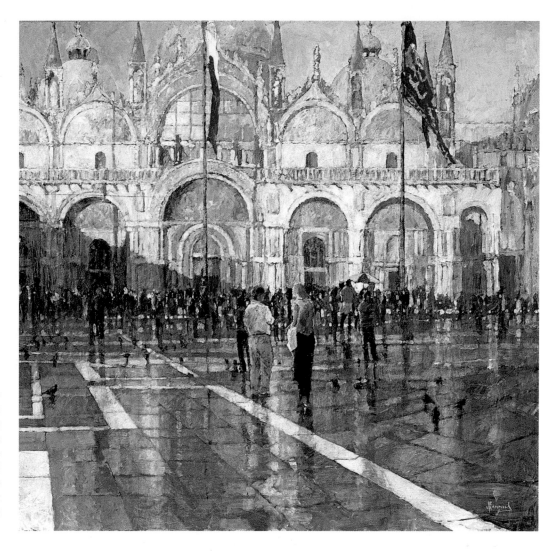

Sparkling Light, San Marco
67 x 71 cm (26½ x 28 in)
There are contrasting
painterly qualities in this
picture – between the
textural, impasto effect used
for the building and the
sequence of thin glazes that
suited the foreground
shadow area.

In contrast, for the strongly lit façade of San Marco, in *Sparkling Light, San Marco* (above), I wanted the picture surface itself to bounce the light back and consequently suggest the feeling of brilliant sunlight. So, here I chose to apply the paint very thickly to produce an impasto surface effect (textured and painterly, with obvious brushmarks). The colour mixes contain a lot of titanium white and are therefore opaque. Moreover, because the paint has been applied in a textural, broken-colour manner, the light reflects in many different directions and thus emphasizes the intensity of the light, particularly as this contrasts with the shadow area on the left.

Interesting darks

Shadows and strong darks within a painting are just as vital to the overall impact of the work as any other parts, but without sensitive handling they can so easily become 'dead' areas. As in *Still Waters, Venice* (page 86), it is the strength of tone and interest achieved in the darks that, by creating such depth and contrast, help intensify the brightly lit areas as well as contributing to the painting as a whole. In general, I think that it is by painting the darks that you create effective lights.

I like to build up the darks gradually, and again I find glazing is the most suitable technique to use. A similar approach can be used to convey a sense of space and depth in a landscape painting, as in *Water's Edge, Cuckoo Wood* (page 86). The feeling of distance and misty atmosphere behind the trees was achieved by applying many layers of glazes, some 20–30 in all.

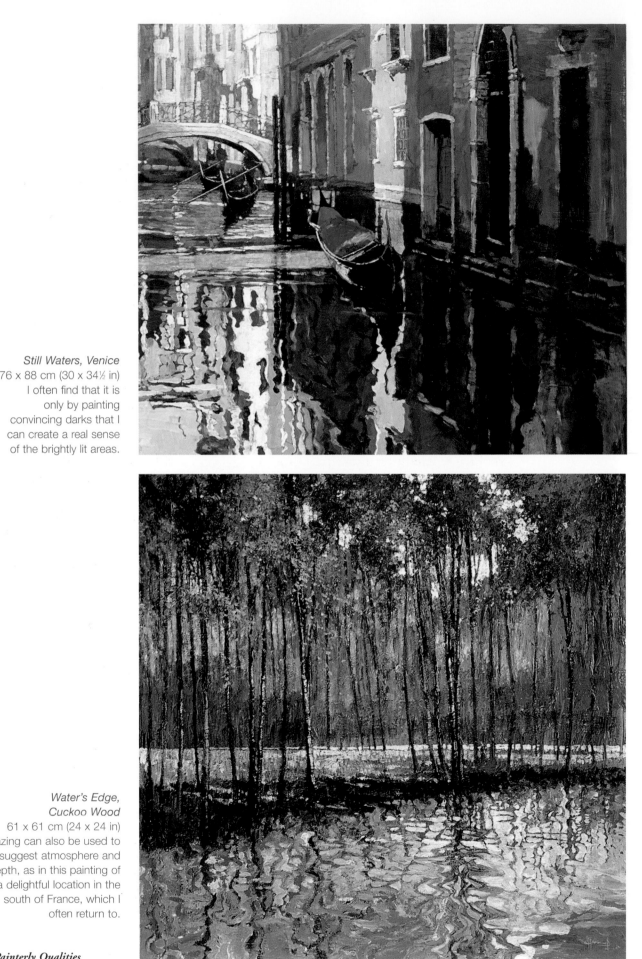

Still Waters, Venice
76 x 88 cm (30 x 34½ in)
I often find that it is
only by painting
convincing darks that I
can create a real sense
of the brightly lit areas.

*Water's Edge,
Cuckoo Wood*
61 x 61 cm (24 x 24 in)
Glazing can also be used to
suggest atmosphere and
depth, as in this painting of
a delightful location in the
south of France, which I
often return to.

Texture

Essentially, there are two types of texture: visual and physical. Visual texture is implied texture, where the different surface effects within the subject matter, such as foliage, rippling water or flaking plaster, are described pictorially. Combined with this is the actual physical texture of the paint (whether it is thick and built up in layers, or used in a more diluted form). For example, you could use short, staccato brushstrokes, broad flowing marks, or a scumbled or dry-brush effect, depending on the surface quality that you want to interpret.

Marks and textures help to describe things. The direction, weight, thickness and character of a brushstroke might suggest that something is round, for example; or heavy, smooth or moving. While obviously colour is always a key factor in interpreting the subject matter, it needs to be colour informed by a certain type of brushstroke. In some instances, especially when working on a still-life group in which the objects are painted life-size, the brushstrokes can virtually model the various shapes and forms. And although this cannot be so when there is a greater difference in scale, such as when painting a landscape, nevertheless the texture and flow of the brushstrokes will still help greatly in conveying the essential characteristics and features of the scene.

I am always very aware of the specific marks that I am making and the way that these relate to the effects and impact I wish to achieve. Thus, in my paintings the physical texture of the paint actually results from my mark-making rather than any conscious decision to impose texture effects. Other artists may work differently by building up areas of texture and so placing a greater emphasis on the paint surface itself, perhaps leading to a more abstract result.

So for me, the degree of texture and the way that this develops is subject-led. For example, to paint a calm and open sky, I usually work broadly and with a large brush; consequently this results in a less textured area than, say, that of a leafy tree in the foreground, for which I would probably use much smaller brushstrokes to build up the picture surface. *Cow Parsley Meadow* (below) is a good example of this approach. You

Cow Parsley Meadow
50 x 61 cm (19¾ x 24 in)
The creation of a particular texture largely depends on selecting the right brush to suit the sort of marks and effects you want to make.

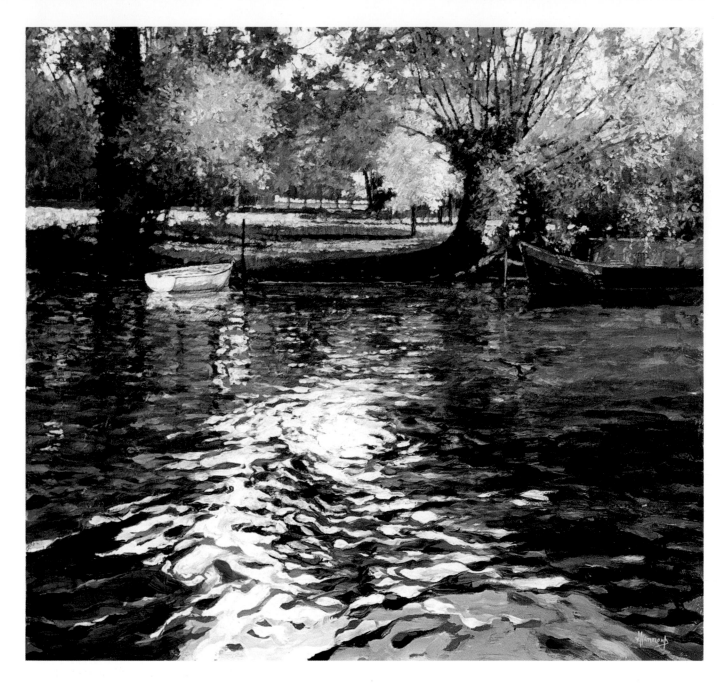

River Mooring, the Avon
61 x 65 cm (24 x 25½ in)
The variety of brushwork
in this painting ranges
from broad, freely applied
marks in the foreground to
smaller, more controlled
strokes further back –
giving a sense of the
textures and of depth.

can see that it includes many different types of directional and textural marks. When I am painting I always have a large selection of brushes available – mostly synthetic hair, but all shapes and sizes, including worn ones, new ones for crisp marks, and specially shaped ones that I have trimmed with a knife. I pick from these according to the sort of marks and effects I want to make.

Texture and colour

Because the character and impact of each colour is influenced in part by the technique used to apply it, I generally consider colour and texture as a single element when I am painting. Colours that are particularly affected by the degree of texture and the method of application include white, which is often used thickly (see page 85) and, contrastingly, shadow colours, which I mostly apply as glazes (see page 83). Usually, the smoother the picture surface, the deeper the colour will appear. A highly textured surface allows the light to reflect in many different directions and thus enhances the brilliance of the colour.

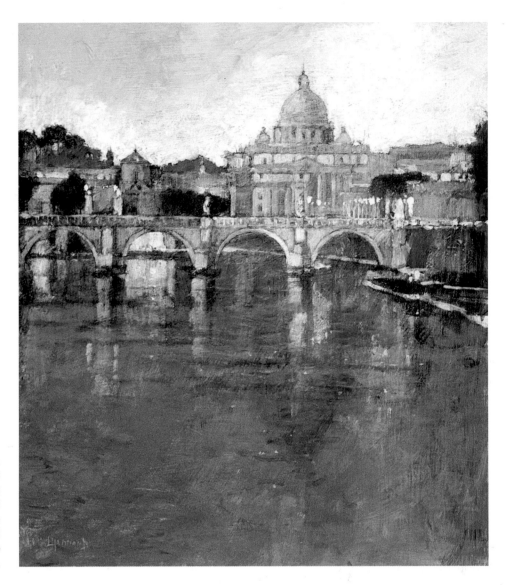

Evening Approach,
St Peter's
35 x 30 cm (13¾ x 12 in)
Here, the paint is brushed
out fairly smoothly to help
evoke the quiet, calm mood
that I felt was appropriate
for this subject.

Evening Approach, St Peter's (above) and *In Bloom, Giverny* (page 90), are two paintings that demonstrate these points. Note that in the first painting I have mostly used thin paint, brushed out fairly smoothly, which evokes a gentle, quiet, calm atmosphere. This particularly applies to the large area of foreground water, where the smooth surface also implies depth. Had I built up that surface with obvious, vigorous brushmarks, it would have attracted more light and surface interest and so decreased the sense of depth. In contrast, in *In Bloom, Giverny*, having established the dark underpainting first with a series of glazes, I then developed the textural foliage using very positive brushmarks. The textured surface also reflects the light and adds some sparkle to the scene.

Exploring textural effects

Texture is something that has to be considered from the very beginning of the painting process, with the choice of canvas or board support and the way that this is prepared. Naturally the type of surface on which you paint – whether this is smooth or textured – will influence the subsequent handling of colour and painterly effects. You may wish to start with a smooth surface and gradually establish different textures on this where appropriate for the subject matter; alternatively you may decide to create your own bespoke textured painting surface depending on how you prime the board or canvas, or develop the underpainting.

In Bloom, Giverny
61 x 55 cm (24 x 21½ in)
The impasto brushmarks in this painting suggest foliage, and also reflect the light and so add an attractive sparkle to the scene.

For some subjects, a textured surface will interfere with the need to apply smooth and subtly blended paint and so the best choice is a prepared canvas with a very fine weave, or a board that has been sandpapered well to achieve the necessary smooth finish. In contrast, to enhance the degree of texture, you could mix some texture gel or modelling paste with the primer. There are various types of texture gel available, including some containing sand, pumice or flint particles. Similarly, as the painting progresses, you could add some texture gel or impasto medium to your colour mixes to enhance areas of texture. And, of course, different implements, such as stiff-hair brushes, painting knives, sponges and pieces of card, as well as different techniques, including dry-brush, scumbling and stippling, will add to the range of textural effects.

I prefer to work on MDF (medium-density fibreboard) rather than canvas, which I feel has a very regular and, in a sense, imposed texture. I prepare the board with two or three coats of acrylic gesso primer. I apply the primer with a large, flat brush, allowing each coat to dry thoroughly before adding a further layer. The back of the board is also sealed with a coating of primer to prevent warping.

Each board is prepared for a specific painting, with the final layer of primer applied in a particular way to suit the texture and character of the subject matter that I have in mind. In most cases I like to see some of the brushmarks of the gesso primer showing through the subsequent colour glazes and paint effects, which I think adds interest and energy to the work.

Boules Court, Winter,
Jardin du Luxembourg
61 x 65 cm (24 x 25½ in)
A contrast of textures will add
interest to a painting, as here, where
there is an obvious difference in the
paint-handling between the
foreground and winter trees.

The Courtyard, Jardin d'Alfabia
50 x 60 cm (19¾ x 23½ in)
With foliage, as with other textures,
it is a combination of the size of the
marks, their colour and the
relationship between them that
actually creates the right effect.

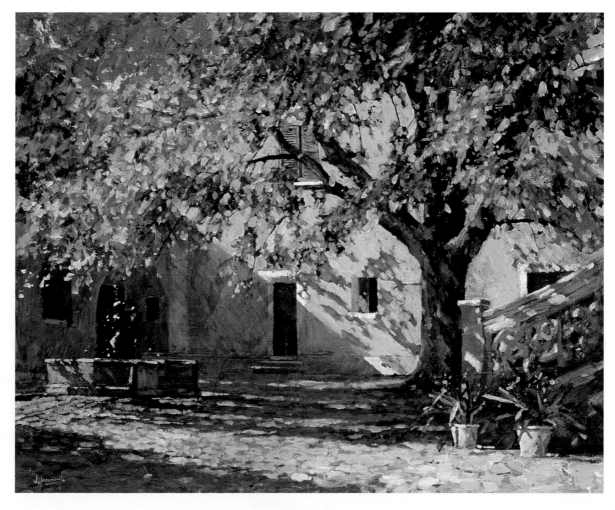

PICTURE PROFILE

Reflections of Honfleur

For me, this was a painting about depth – depth of colour, tone and texture. The main interest and challenge was in capturing the nature of the water, with its deep shadows and reflections, and so this was the area I decided to focus on. To help achieve the right tonal balance, and as a starting point for the necessary painterly qualities, I began by making an underpainting in a strong blue colour. In fact, I always start my paintings in this way, by blocking out the white primed surface and creating a colour base that will suit the mood and subject matter I have in mind.

To enhance the feeling of depth and tranquillity, the choice of colours in this painting is deliberately limited. But, as you can see, it is enlivened here and there by accent colours – little touches of red/orange in the café and among the boats, for example, and similar glints of colour in the water. This creates a lovely rhythm of colour throughout the painting. And essentially it is a painting that has been built up layer on layer. The hazy distant areas, such as the background hill and the buildings on the right-hand side, were painted with thin, loose applications of colour, and then more layers were added as I worked towards the foreground.

As usual, I worked from dark to light, with the darks developed as a sequence of glazes and the highlights applied as impasto. The reflections in the water were made with an interlacing of thick impasto marks and subtle glazes.

Reflections of Honfleur
61 x 65 cm (24 x 25½ in)

5 Interpretation

In effect all paintings, even the most detailed representational ones, involve a degree of interpretation. It is not possible to paint something exactly as it appears, and therefore when tackling any subject matter it is necessary to make certain judgements, and in consequence modifications, in relation to what is seen and understood. But I would go further than that: in my view, interpretation is an essential part of painting. After all, what is painting if it is not the expression of an individual response to something?

The nature of interpretation and its impact result from different skills and factors allied to both the technical and emotional response to the subject matter and the specific challenges it presents. Throughout the history of art, the greatest challenge for figurative painters has been how to capture convincingly an impression of the three-dimensional world on a two-dimensional surface. And that problem is exacerbated if, additionally, you want to convey feelings, sounds and so on in your work. What makes each artist

(Opposite)
Swathe of Blue
61 x 43 cm (24 x 17 in)

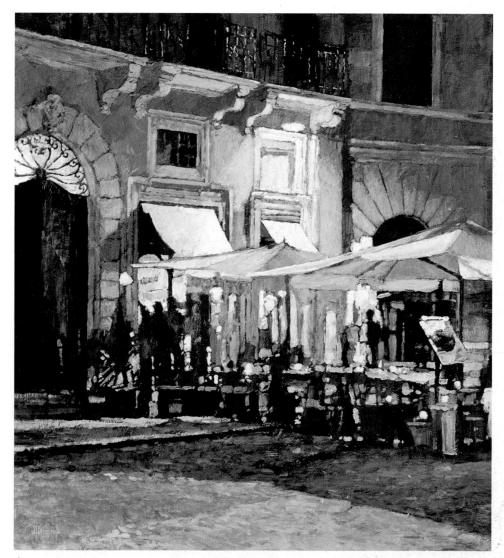

Buona Sera Roma
46 x 41 cm (18 x 16 in)
Sentiment and emotion are sometimes the main reasons for making a painting. This was a kind of farewell painting to one of my favourite restaurants in Rome.

unique is the way that he or she solves those problems and suggests and interprets various qualities and ideas through the medium of paint.

As in everything, experience counts for a huge amount. Each new painting will inevitably benefit from ideas, techniques and colour mixes used in previous works, and in turn this should add to your confidence and allow a more fluent approach to the painting process. Ideally, it will also encourage a greater freedom in interpreting subjects in an individual and sensitive way, particularly when painting in acrylic, which allows you to keep moving ahead all the time, unhindered by breaks to let the paint dry.

A personal response

A personal response is important. In fact, whenever you paint you cannot deny some kind of personal response, but of course it is a question of how much you allow this to come through in your paintings. You could, for example, adopt a photo-realistic approach, or at the other extreme choose abstract expressionism. However, like myself and many other artists, you will probably find that your style lies somewhere in between those two extremes – figurative work, but with a distinctly individual way of looking and interpreting. Ultimately you have to be happy with your style and approach to painting, and this usually means arriving at a compromise between work that suits you perfectly as an artist and paintings that communicate with other people.

Essentially, your personal response is determined by the decisions you make: decisions concerning the subject matter and what you feel is important about it, and equally the many intellectual and technical decisions that you have to make during the course of a painting. Again, this is a process that is much influenced by experience and confidence. Initially, there is a tendency to rely on lots of information for each painting and consequently to involve more detail and deliberation than may be necessary. But gradually you find that you are able to edit subject matter and so concentrate on the key elements – the qualities that most impress and inspire you. Thus your response becomes more focused and individual.

Golden Breeze, Val d'Orcia (opposite) perfectly illustrates this approach, I think. With this subject the qualities that immediately impressed me were the lovely warm breeze, the sounds of insects, and the delicate seedheads floating all around. In my view that first impression is always important and for me it is that particular moment, feeling and sense of place that I want to capture in a painting. And it is those qualities, or what I usually think of as 'triggers' for the subject, that are the vital ones to note down, photograph and sketch.

Remember, it may be some considerable time before the reference material is used for a painting, so it is essential that it is recorded in a way that will jog your memory and bring back those original thoughts and emotions. Then, as in *Golden Breeze, Val d'Orcia*, it is easier to paint with feeling and conviction. In this painting you will see that I have exaggerated the flow and rhythm in the long grass to draw attention to the breeze; I've also included little staccato brushmarks dotted across the field – a sort of 'visual noise' to suggest insects and seedheads.

Free expression

Painting is a combination of inspiration, intellect and technical skills, all of which contribute to a certain mode of expression. Naturally, the way that you apply paint to canvas or board will have a tremendous influence on the way that the painting is 'read'

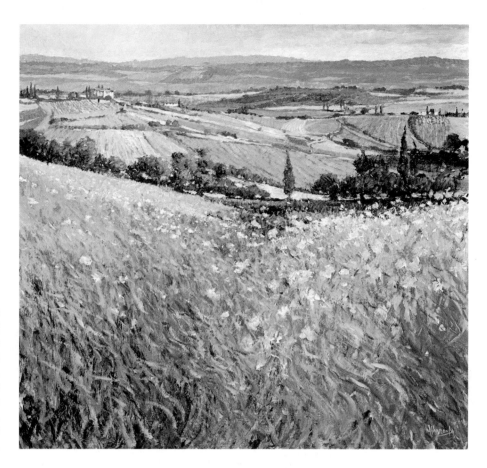

Golden Breeze, Val d'Orcia
68 x 72 cm (¾ x 28½ in)
A successful painting will do more than simply show us how something looks. Here, additionally, I wanted to convey a sense of the warm breeze, the sound of insects, and the delicate seedheads floating all around.

and appreciated. For instance, vigorous, freely expressed mark-making will create a different mood and response than calmer, more controlled strokes. Paintings must always involve passion and feeling, but arguably the best artists exercise some restraint in their approach, using simple but very meaningful brushmarks and passages of colour. Often, as the saying goes, 'less is more'.

Obviously, the choice of brushes is the most influential factor in determining the character and expressive quality of a paint surface. Stiff-hair brushes will create a more textural mark, for example, while large brushes encourage a freer way of working, with less emphasis on detail. Similarly, the amount of drawing and initial preparation for a painting plays a decisive part. As I have mentioned, I tend to do more drawing for architectural subjects, as the shape and main features of buildings must be fairly accurate if they are to look convincing. But otherwise I keep the drawing fairly limited – just an indication of the main elements of the composition. The danger with doing a lot of drawing is that you are then tempted to simply colour it in, and so the painting loses its vitality.

The great advantage with acrylic, of course, is that you can work very freely and apply paint layer over layer, in any way that you wish. There is no disruption to the working process while you wait for the paint to dry, and no limitation on technique by having to keep to a certain procedure, such as working dark over light in watercolour. Again, this encourages free expression and indeed makes it much easier to respond to unexpected ideas that occur while you are working on a painting.

This happens especially with colour in my paintings, I find. Often, having mixed and applied a new colour, I suddenly notice a relationship between that colour and another one; a relationship that I had not envisaged. Then it is a matter of deciding whether to accept those colours or change them. In fact, that is the sort of decision you have to make with every brushmark that you add to a painting. Does it enhance the work, or will it have a negative effect?

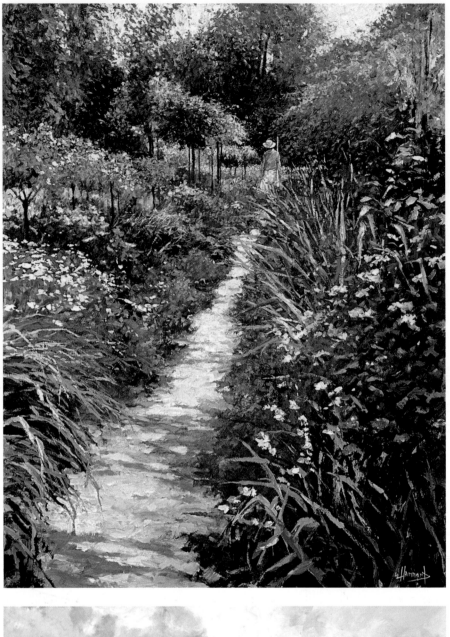

In the Footsteps of the Gardener
80 x 60 cm (31½ x 23½ in)
I always start by considering the main elements of a subject and the sense of three-dimensional space before getting too involved with the brushwork.

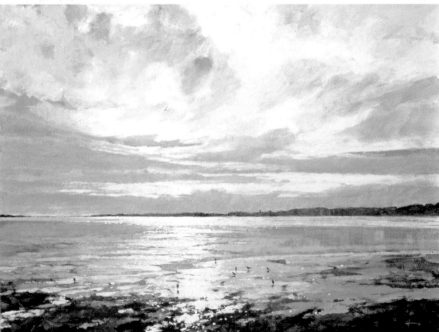

Morning Walk
61 x 80 cm (24 x 31½ in)
Coastal scenes, with their large expanses of sky and sea, are ideal for a freer, more expressive approach.

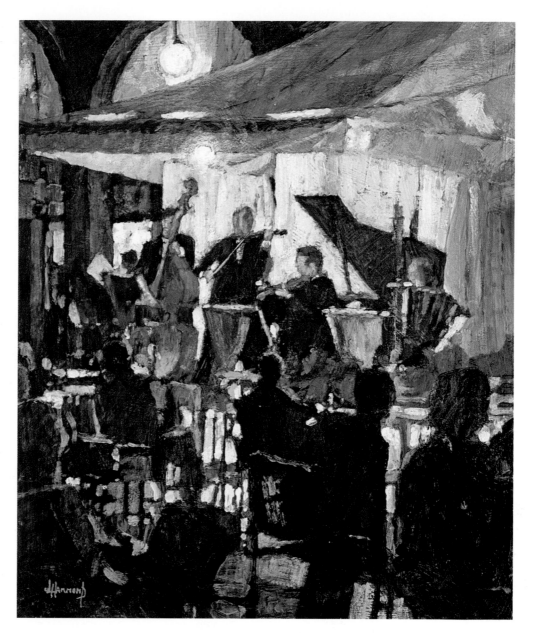

Expression and communication

As I explained in Initial Considerations (page 10), I believe very firmly that painting is a means of sharing ideas. But those ideas must genuinely excite and interest the artist, rather than simply being subjects that are commercially popular. I always look for subjects that are challenging and inspirational in some way, because I know that if I am not enthusiastic about an idea I am unlikely to paint it to the best of my ability.

The other point to note is that a painting can communicate on various levels and people can appreciate it for different reasons. Sometimes people relate to a painting because it evokes associations with a place or situation that they remember fondly; the subject matter and skill in interpreting it are much admired and appreciated. But equally there can be interesting qualities beyond the obvious content, mood and narrative element of a painting – within its specific handling of colour and paint, for example.

Often, when I look at a painting, what excites me most is not so much the overall impact as perhaps a small area of sensitive brushwork – the texture of paint somewhere, or the relationship of certain colours. In fact, it is qualities such as these that usually distinguish an impressive painting from one that is maybe technically sound but otherwise unconvincing.

In the Shade
31 x 30 cm (12¼ x 12 in)
I remember distinctly the
sound of these hens
clucking cheerily in the
shade of the trees, and this
was a key factor in helping
me re-create the scene
as a painting.

Low Sun, Across the Bay
61 x 67 cm (24 x 26½ in)
Often, what initially
appears to be a very simple
subject is actually full of
subtleties: take advantage
of these to create an
interesting painting.

Simplification and exaggeration

One of the reasons I believe in location work is that it provides an opportunity to spend time observing and thinking about the subject matter. Additionally, such an assessment enables you to identify the basic forms and structure within the subject; from this you can decide which aspects you need to focus on and which are less significant in contributing to the way that you want to interpret the scene. With a complicated subject especially, you need to look beyond the surface appearance so that you can start from the fundamental components. By understanding those key underlying shapes, you are more likely to develop a successful painting.

In a landscape or seascape view, as in *Low Sun, Across the Bay* (opposite), the main divisions of the subject, and therefore its basic composition, are often very apparent. So here perhaps, instead of the design being the key feature in interpreting the subject, the emphasis is likely to be on capturing a particular mood and effect of light through the use of colour and painterly techniques. But, as you can see in a subject such as *Nearing St Peter's* (below), some scenes can be far more complex in their content and design.

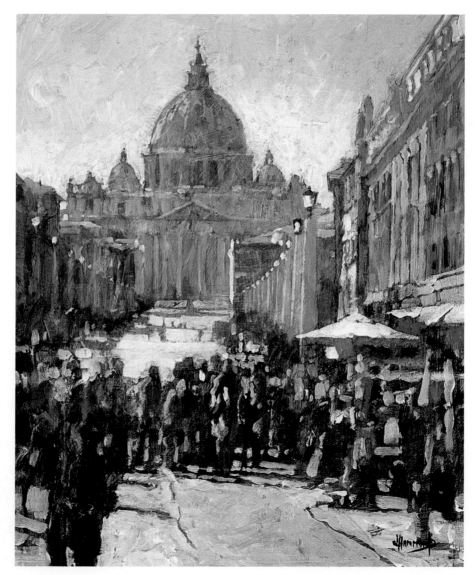

Nearing St Peter's
30 x 25 cm (12 x 10 in)
Some subjects are complex and it is a matter of deciding which aspects to concentrate on. Here, I decided to focus on the groups of figures in the foreground.

A close analysis shows that this subject is essentially about depth, with three main areas to consider: the distant St Peter's; the receding buildings on either side in the middle ground; and the crowd of people in the foreground.

I used the central mass of buildings, with its exaggerated perspective, to create a strong compositional device to link the two important elements – the crowd and the distinctive shape of St Peter's. I was then able to decide which aspects to simplify or exaggerate in order to achieve the effect I wanted. You will see that I have enhanced the sense of depth by subduing the colour and detail on the buildings and columns in the middle ground, so placing most of the emphasis on the foreground figures. But even here it is noticeable that very few of the figures are painted with any great definition. By focusing on and clearly defining a couple of figures within the crowd, I felt that, in conjunction with those, the rest could be suggested with fewer and looser brushstrokes – any further details would be filled in by the viewer's imagination.

London Reflections, St Martin's Place
50 x 41 cm (19¾ x 16 in)
There is a nice contrast here between the well-observed and carefully drawn buildings and the much freer treatment encouraged by the reflections.

Shape and meaning

The particular shapes used, combined with the way that these divide up the picture area, can have a significant impact on the meaning and mood of a painting. Shapes can create a balanced, calm effect, for example, or add to the drama and tension of an idea. The accuracy of the different shapes, and whether they can be expressed in a much freer and more personal manner, depends on the type of subject matter. Obviously, with a subject such as *London Reflections, St Martin's Place* (opposite), the shapes need to be well observed and carefully drawn, otherwise the painting will not make sense. But in a landscape, such as *Lavender Plateau* (below), there is far more scope to manipulate the shapes in order to add to the impact of the painting.

In *Lavender Plateau* I have exaggerated the curve of the path and the undulations in the landscape to help me create a greater sense of interest and depth. Moreover, this is further emphasized by the change of tone beyond the ridge in the first field and also by

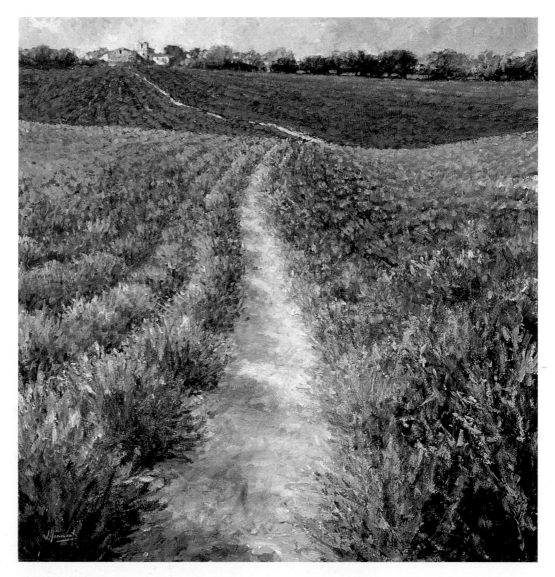

Lavender Plateau
61 x 57 cm (24 x 22½ in)
In a landscape, there is far more scope to manipulate the shapes in order to create an effective result.

the flow of the rows of lavender as they fade into the distance. There are lots of opportunities to adopt this sort of approach. But if you are not confident about making such decisions straight away, try working through a sequence of sketches first, simplifying and experimenting with the main shapes to find a solution that you like.

Emphasis

Generally, the way to draw attention to part of a painting is to emphasize the detail, colour or paint handling within that area. Additionally, you can enhance the effect by simplifying or subduing the content in the surrounding area. And interestingly, in that respect there are similarities with the method that I often use to create a dramatic effect of light – where it is not just a matter of exaggerating the brilliance of the light, but also

Early Rising, Cuckoo Wood
60 x 41 cm (23¾ x 16 in)
Size and shape are important aspects for initial consideration, as they have a significant influence on the impact of a painting. I chose a portrait format for this subject because I wanted to emphasize the feeling of height and growth.

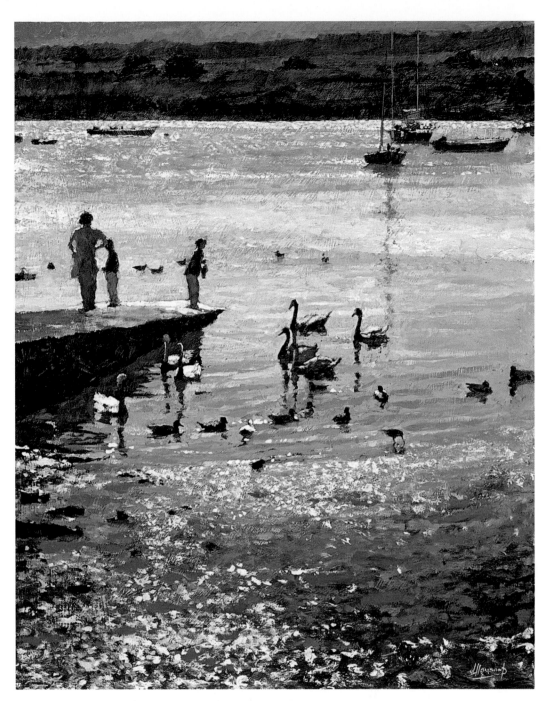

Swan-Watching, Topsham
58 x 46 cm (23 x 18 in)
In order to focus attention on the light reflected by the water, I decided not to include the sky area in this painting.

of strengthening the dark tones that surround it. Often, to achieve the right level of interest and impact in a painting, it is necessary to maximize the contrasts in colour, tone, shape or other qualities.

Early Rising, Cuckoo Wood (opposite) is an example of a painting in which I have emphasized a number of aspects in order to create a more dramatic result. One thing that especially impressed me about this subject was the soaring canopy formed by the tall trees. So I decided to exaggerate that effect slightly, partly by lowering the horizon and partly by making the trees even taller than they actually were. Also, to intensify the effect of the light streaming through the canopy, I strengthened the blue in the foliage. The position and spacing of the trees was important; in fact I have not included every tree that was there. And I decided to leave out much of the undergrowth beneath the trees, simplifying the area and adding a misty glaze to imply a greater depth.

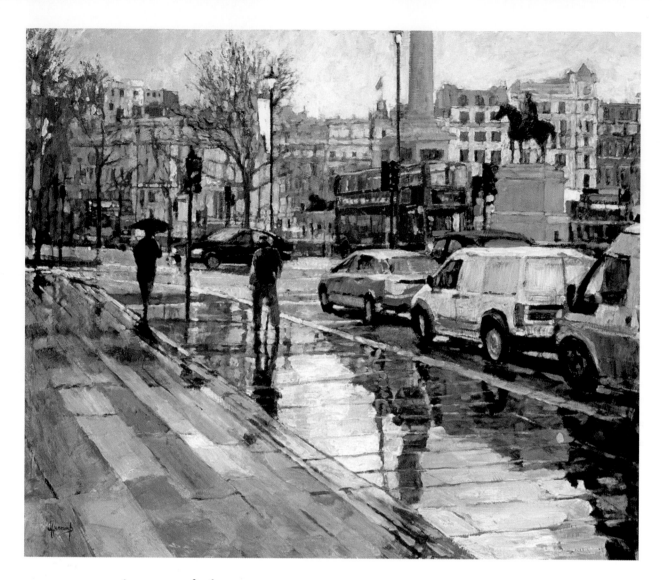

A sense of place

Success in capturing a sense of place depends on a number of factors, not least your instinctive response to the subject matter and the consequent thoughts and feelings you have about it. Naturally, presented with the same scene to paint, each artist will respond in a slightly different way, according to which features and qualities of the subject they are most sensitive to and impressed by. It is a question of identifying the things that, in your view, contribute to the character and mood of a subject. Sometimes those qualities are very obvious, while on other occasions they are a lot more subtle.

Light is often the quality that most influences our response to a subject (see Key Qualities, in Inspiration, page 13). But equally it could be a particularly interesting colour combination or perhaps the subject matter itself that creates the distinctive sense of place. Having identified the qualities to focus on, much then depends on how well they can be interpreted in paint. The right choice of colours and techniques is crucial in helping to create work that evokes the response you experienced when you first saw the subject. Success here will rely both on your skills and knowledge, and on your ability to paint with expression and feeling.

Sensitive brushwork

Light Haze, Cotswold Meadow (opposite) is a painting in which light and mood are key qualities and therefore it was particularly important to consider the tonal contrasts and

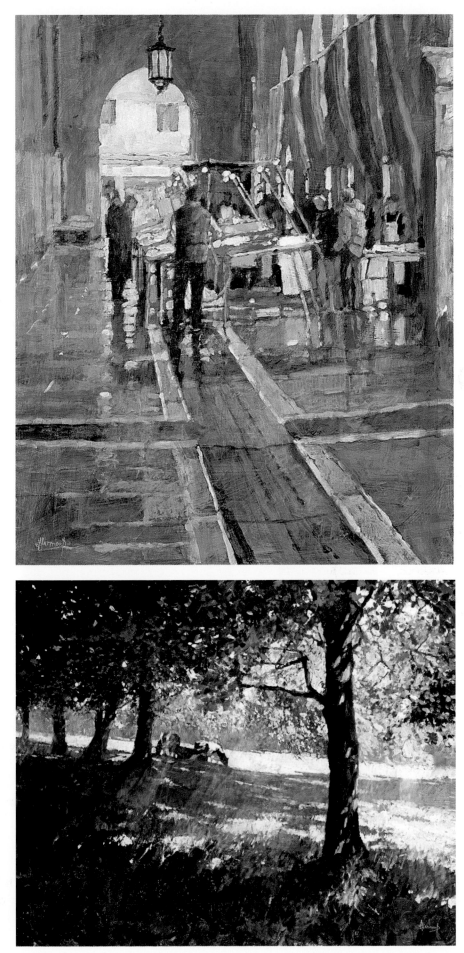

*The Pescheria with
Green Awnings*
38 x 31 cm (15 x 12¼ in)
Whatever the subject, and
particularly at well-known
locations such as this,
I like to consider a number
of viewpoints before
deciding on the best
spot to work from.

*Light Haze,
Cotswold Meadow*
55 x 70 cm (21½ x 27½ in)
It is always important to
adapt brushwork and
techniques to suit the
texture and character of
different surfaces. In this
painting, for instance, notice
the use of milky glazes to
suggest the effect of light
filtering through the trees.

the texture and character of the paint in different areas. The foliage and foreground areas, for example, have a more textural feel, whereas to create the effect of light filtering through the trees and the strong sunlight beyond, I have used a sequence of transparent, milky glazes.

On the other hand, in *Celebrazione, Contrada della Torre* (opposite), the sense of place is largely determined by the subject matter itself. Here, the main challenge was to convey the feeling of energy and movement, which I think is helped by the waving flags, the basic

The Blue Bench, Montefalco
60 x 42 cm (23½ x 16½ in)
Again, this subject is all to do with light and choosing appropriate techniques to create the necessary contrasts, such as the use of layered glazes to build up interesting darks and shadows.

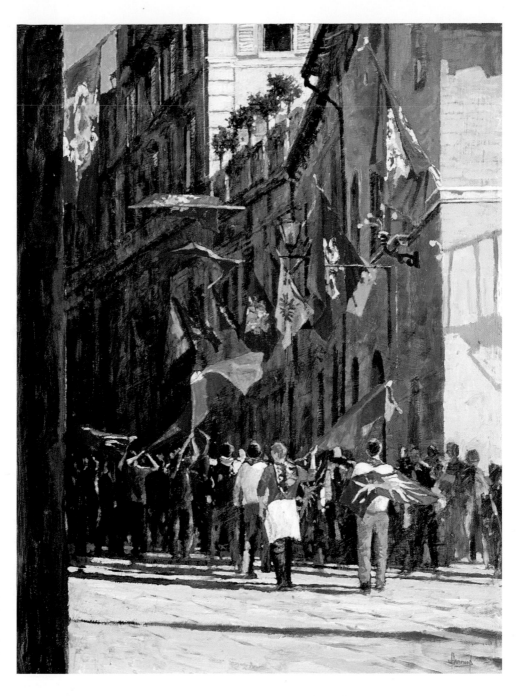

Celebrazione,
Contrada della Torre
80 x 61 cm (31½ x 24 in)
Here, the sense of place is
largely determined by the
subject matter itself, with
the waving flags and the
strong suggestion of energy
and movement.

perspective within the composition, and the flow of the figures. All of these elements lead the eye into the distance and leave us curious about where the procession is heading. The format of the painting – the fact that the shape is portrait rather than landscape – adds to the sense of celebration and movement, I think. I doubt if it would have been as successful the other way round.

Contrastingly, *The Blue Bench, Montefalco* (opposite) was a less time-specific subject, so gathering reference information was not a problem. Here, once again, the quality that defines the sense of place is the light, and particularly the way that the bench itself is framed by strong shadows. In fact, I have accentuated those shadows in order to give the subject a little more drama and impact. As in *Celebrazione, Contrada della Torre* (above), this painting was built up from dark to light, starting with glazes for the shadow areas and gradually working towards the lightest parts and highlights, using increasingly thicker paint.

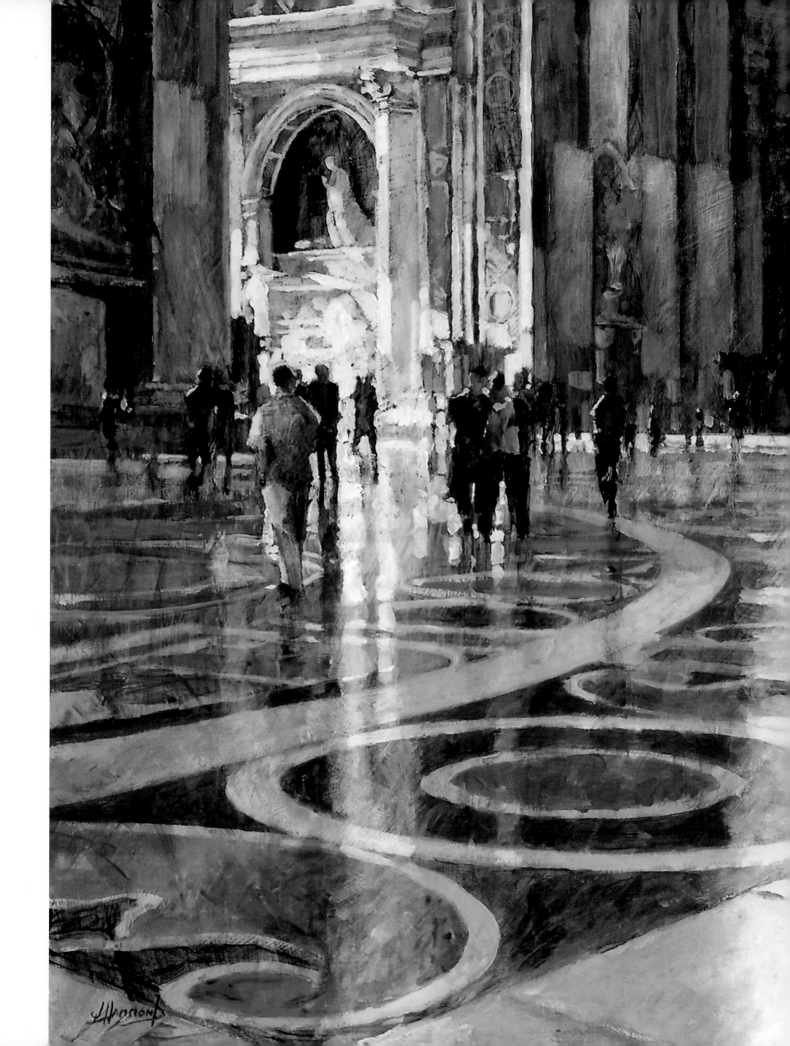

6 Creating Impact

In order to communicate its content and ideas effectively, a painting must somehow attract people's interest. However, this is not to say that every painting must necessarily incorporate some kind of exaggerated shock tactic to draw attention to itself. Obviously, different paintings have different levels of intensity. But there should always be something in the colour, narrative or technique that engages the viewer and encourages him or her to investigate the painting further.

To a large extent, the impact of a painting is determined by its subject matter. In my view the impact should be an intrinsic part of what is seen, and it is essentially determined by the qualities that initially attracted you to the subject matter. Although, as I have explained on pages 104 and 105, some emphasis and simplification may be necessary, I do not believe in deliberately enhancing the overall effect by grossly distorting aspects of the subject matter or inventing and introducing things that were not there.

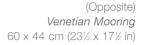

(Opposite)
Venetian Mooring
60 x 44 cm (23½ x 17½ in)

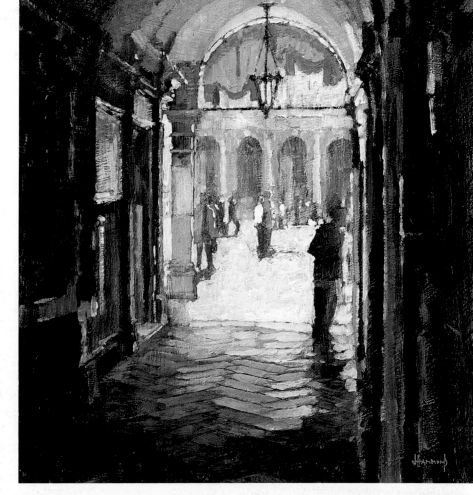

Window-Gazing
35 x 30 cm (13¾ x 12 in)
As well as the obvious contrast of light and dark in this painting, which draws you in, there is a balance of shapes within the composition and a strong sense of rhythm and movement created by the figures.

Always, the most important element to stress is the emotional quality. A church interior, for example, will have a different emotional feel to an open landscape subject, and it is vital to capture this in the painting.

Balance and contrast

Generally, most aspects of painting have to be considered in terms of balance and contrast – for instance when handling tone, colour and composition. These qualities have to be balanced individually, and they must also work as a whole. It is primarily the overall variations in balance and contrast, whether subtle or strong, that give a painting its distinct character.

In *Prinsengracht* (below), for example, there is a very obvious use of tonal balance and contrast, working from the brightest white to the deepest dark tones. Similarly, in the composition, the strong verticals of the trees and their reflections are countered by the horizontal lines of light on the surface of the water. Also, the splayed effect of the tree branches above, balanced with the wavy ripples in the extreme foreground, are useful

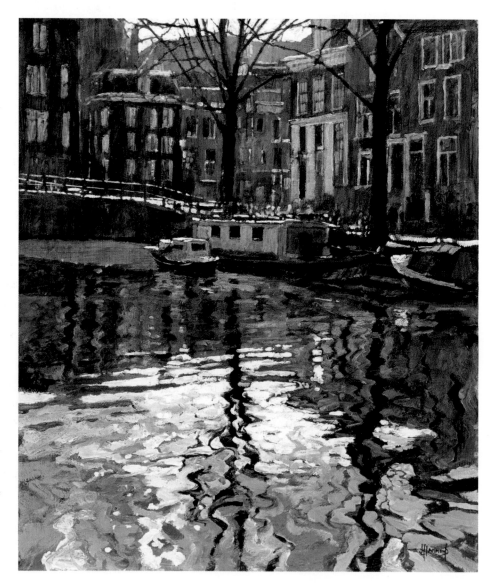

Prinsengracht
50 x 41 cm (19¾ x 16 in)
I was immediately drawn to the balance and contrast of horizontal and vertical shapes in this subject.

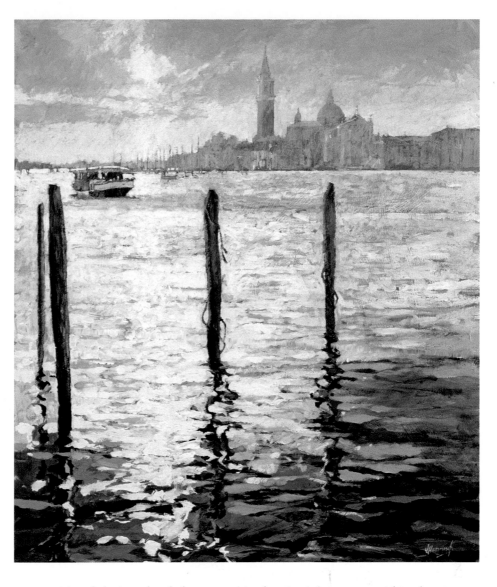

The Vaporetto
72 x 61 cm (28½ x 24 in)
I like to create a kind of
visual journey in every
painting, leading to a
particular point of interest –
in this case the break of
light above the vaporetto.

compositional devices that help to contain the viewer's interest within the picture area by preventing their eyes from moving up and out.

Alongside this, I think the decision about where to crop a painting, and consequently what happens at the very edges of the board or canvas, must always be carefully considered. In my studio, I have a pile of old frames and quite early on in the painting process I like to find a frame that will fit the picture I am working on, so that I can test what is happening around the edges. It is important to remember that a narrow strip at the edges will be lost beneath the rebate of the frame when the work is eventually framed.

Points of interest

The established convention is that each painting should have a focal point or centre of interest – an area within the composition that attracts the viewer's attention – and that the composition should lead the eye there. This is a practice that I normally adopt, and in fact I think sometimes a painting benefits from more than one focal point, so that in effect the design incorporates several visual 'journeys'. What is essential to the success of any painting is that it contains passages that are specific, in contrast to areas that are handled in a more general way.

The Vaporetto (above) demonstrates this kind of visual journey. Everything is designed to direct your interest from the foreground to the distance – up through the line of posts,

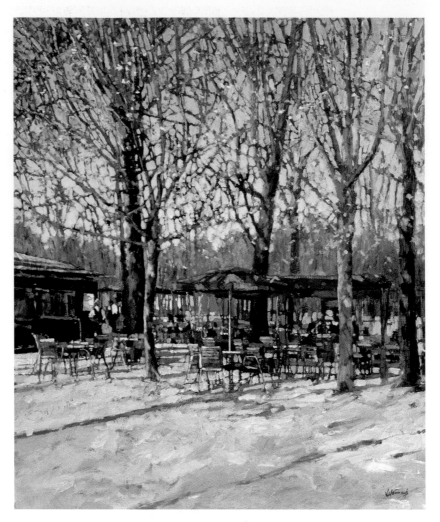

Early Spring, Paris
60 x 50 cm (23½ x 19¾ in)
Here, the main point of
interest is the central area of
activity around the café,
which is emphasized by the
strong colour of the parasols.

across to the vaporetto itself, and on to the buildings and the break of light above. In turn, the shaft of light leads the eye back down to the foreground and so completes the journey. The posts, the boat and the shaft of light are the specific elements that give the painting its mood and identity. Without them, there would be no real 'punch'.

Themes and variations

Often, there are many variations in the way that something can be interpreted and it is worth returning to the subject to explore an alternative approach. You may want to try the same subject from a different viewpoint, for example, or in more dramatic lighting conditions. Some artists never tire of a particular location or source of subject matter and are able to paint many interesting variations.

A key requirement of any painting is that it is individual and engaging in some way. But this cannot be so if you feel you know everything about the subject and find it unnecessary to make any further reference observation or studies. Of course, there is scope to work from the same subject over and over again, as long as you are not in fact repeating the same painting. Mostly, my paintings are single expressions of a subject because I am interested in what is happening at a given moment in time. Even so, I do occasionally revisit a subject or try a similar theme, as with *Sidmouth Sands* (opposite, above) which led to the painting *Low Tide Walk, Sidmouth* (opposite, below), for instance. While working on the first painting, I came across aspects that I felt I would like to develop more fully in the subsequent painting.

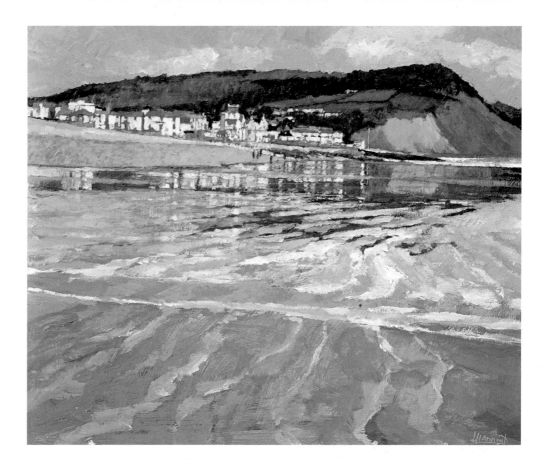

Sidmouth Sands
42 x 50 cm (16½ x 19¾ in)
I normally paint only a single version of a subject because I aim to capture a particular moment in time. But, interestingly, this painting encouraged me to revisit the subject and work on a larger scale (see below).

Low Tide Walk, Sidmouth
61 x 91 cm (24 x 36 in)
While working on Sidmouth Sands, I came across aspects that I felt I would like to develop more fully in a separate painting, and here is the result.

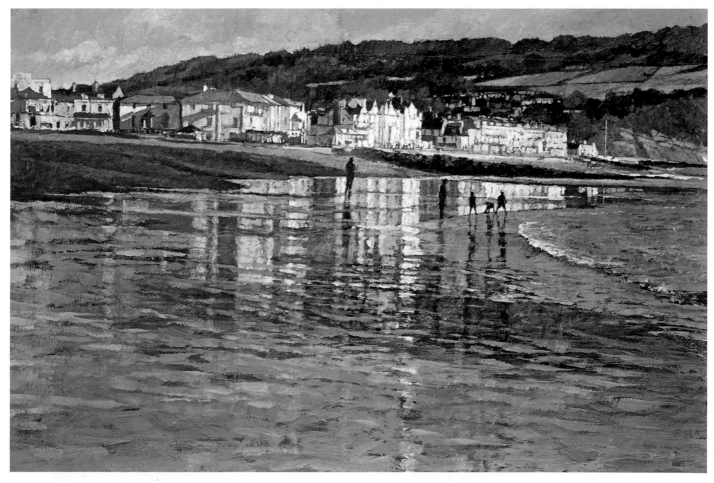

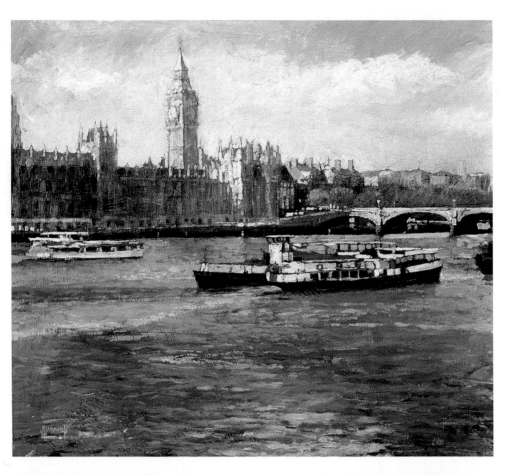

Clear Day, from the Albert Embankment
40 x 44 cm (15¾ x 17¼ in)
Especially in a city, you can usually find an interesting variety of subjects to paint within a relatively small area. Compare this painting to *Across Westminster Bridge* (below), for example.

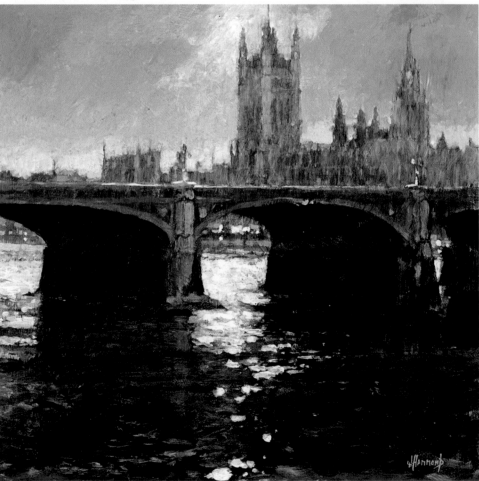

Across Westminster Bridge
30 x 30 cm (12 x 12 in)
When exploring ideas in a city, you will find that one painting will inform another; gradually you will get to know the environment, and the colours and techniques that work best.

Resolving objectives

It is best not to define your objectives too precisely, for there should always be an opportunity to capitalize on things that happen during the painting process, and in any case few paintings develop according to a precise plan. In my experience, the painting process divides into three main phases. A painting begins with the enthusiasm and thrill of a new challenge. Then comes the (sometimes frustrating) long middle period, often a real test of tenacity and painting skills, in which all the really important design and aesthetic elements are resolved. And finally there are those little touches and flourishes of light that bring a painting to life.

Painting is basically about the relationships between different elements – colours, shapes and so on – and thus quite a lot of time is spent assessing, adjusting and readjusting things. Most artists start with the distinctive area or feature that originally

The Parasol, Valensole
46 x 45 cm (18 x 17½ in)
The choice of colours is always a key factor in resolving your aims for a painting. My objective here was to convey the joyful mood of this scene by using an appropriate colour combination, which consisted of yellows, blues and lavenders.

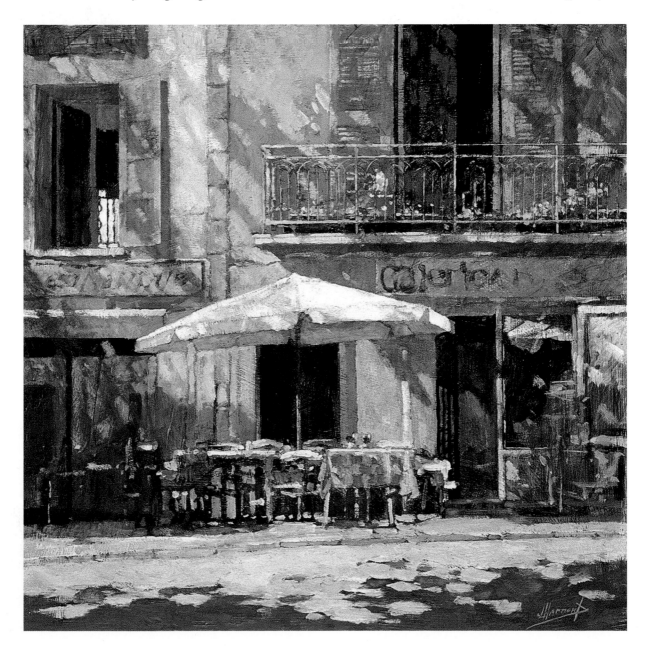

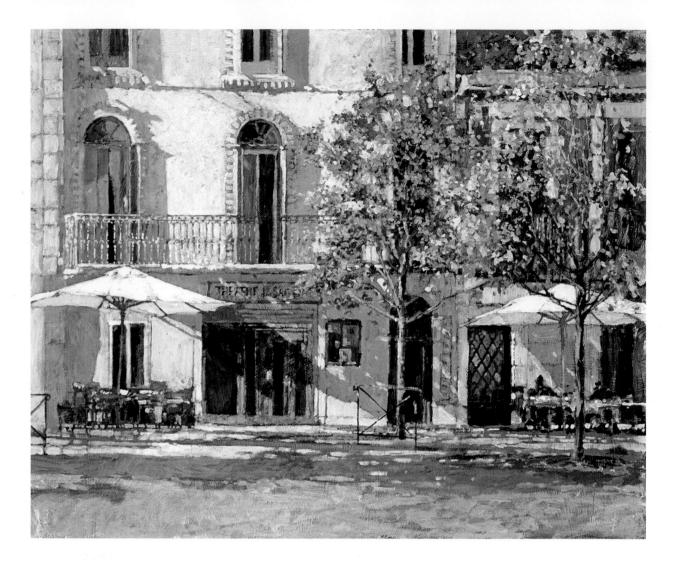

Theatre Parasols, Orange
50 x 61 cm (19¾ x 24 in)
All paintings involve stages of development and, in some instances, quite radical changes. In this painting, for example, the trees could not be considered until I had finished the work on the buildings behind, which required much careful draughtsmanship and a succession of overlying coloured glazes.

attracted them to the subject matter, subsequently developing the painting in relation to that. However, to begin with they are careful not to finish any one area to a high level of detail, because this in fact adds to the difficulty of considering the painting as a whole and will often involve reworking the passages that were presumed to be finished.

My advice, therefore, is to resolve your objectives for the work slowly, aiming to develop the whole painting at the same pace. As I have stressed, the great thing about using acrylic is that it is very easy to make changes, so this should encourage a certain amount of confidence and freedom of approach. For instance, inevitably in some paintings there will be times when it is necessary to take very drastic steps to re-establish the objectives you had in mind. This could mean that, in order to create an overall sense of unity and impact, some parts that you were initially very satisfied with have to be blocked out and repainted.

Making changes

The simplest way to make changes is to let the area dry and then paint over it, adjusting the colour mixes and techniques as necessary. But if part of a painting requires more drastic action, such as redesigning or redrawing, then probably the best approach is to take it right back to the beginning and start with a fresh coating of acrylic gesso.

Sometimes the build-up of paint creates quite a texture, and this is distracting and out of context. The best solution is to rub across the area with some sandpaper until you have the sort of surface texture that is appropriate, and then repaint it to fit the surroundings.

Similarly, there are other devices that artists sometimes use to check what is wrong with a painting and make the necessary changes. For instance, when I was at art college there was one tutor who, if he reached an impasse with a painting, would select a key feature and paint over it with its complementary colour. This would completely transform the painting and inspire him with fresh ideas about how to develop the work further. Other artists like to turn a painting upside down or view it as a mirror image to check the effectiveness of its composition and colour relationships. But I would advise against making too many modifications, however easy this might be with acrylics. Generally, a feature of the most successful paintings is their spontaneous approach. In contrast, lots of alterations can lead to a rather laboured result. With this in mind, having learned from your mistakes, sometimes more dramatic action is necessary, and the best approach is to start again.

Freedom and control

Some subjects lend themselves to a very personal, expressive approach; others require more control. With every painting, important decisions have to be made concerning the paint handling, colour intensity and similar factors that determine the character and appeal of the work. You have to judge just how far to go – too little or too much individual expression and the intended impact will be lost.

I greatly enjoy paintings such as *Venetian Mooring* (page 112) because the subject matter allows tremendous freedom for the most part, and this is enhanced by the contrast with certain features that require a particular degree of accuracy and control. It is essentially these specific shapes – the gondola in this painting, for example – that give the work meaning and create a point of reference for more abstract passages, such as sky or

Towers of San Gimignano
68 x 72 cm (26¾ x 28½ in)
The San Gimignano skyline is a very familiar image and therefore has to be treated with a certain amount of discipline and control. However, the undulating landscape below the town offers much more freedom, both for painterly expression and in terms of manipulating the content to lead the eye into the distance.

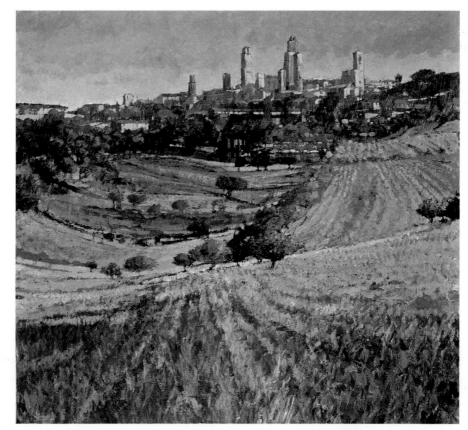

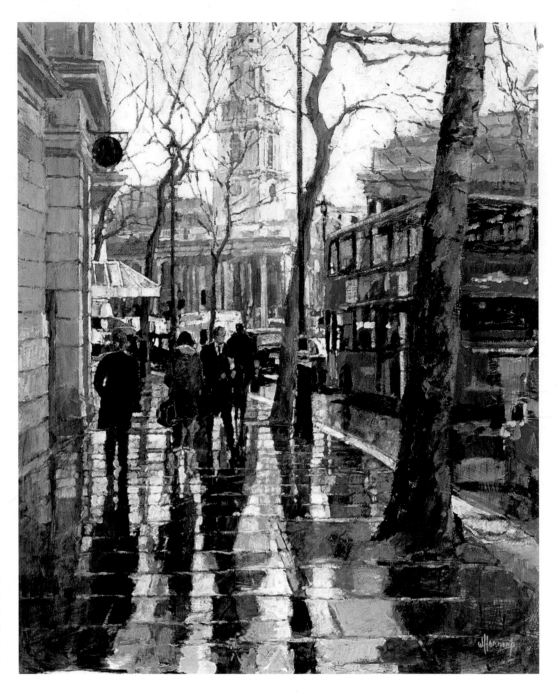

The Wet Pavement
61 x 50 cm (24 x 19¾ in)
Here there are buildings
that must be drawn
accurately, while the wet
pavement below invites a
much looser treatment.

water, which can be treated in a very free way. These are the sort of areas that provide an opportunity to unleash all your expressive powers and enjoy the physical properties of the paint itself.

The whole picture

Working through stages of development, while at the same time keeping in mind the unity and integrity of the whole picture, is a difficult process, especially if you are not an experienced painter. However, there are several techniques that can help. With the underpainting, for example, it is a good idea to work fairly broadly, paying particular attention to the colours used and the way they will influence subsequent colours and ultimately the overall mood of the painting.

Also, it helps to think about the tonal range of the painting at an early stage, identifying the very brightest areas and, at the other extreme, the most intense darks. Try

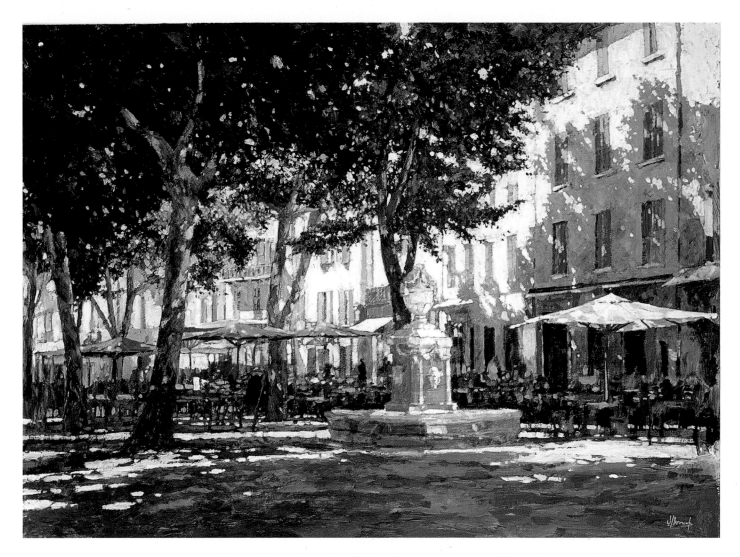

Cotignac Shade
60 x 80 cm (23½ x 31½ in)
As discussed in different sections of this book, the success of every painting depends on how well the various aspects of colour, tone, shape, texture and so on work together to express the artist's intention.

working this out in a sketch first if you are not confident about starting directly in paint. Often, the other main concern is with the initial drawing. Having made a useful foundation drawing, you may be worried about losing this, and consequently the basic structure of the composition, when the first layers of paint are applied. But this is not such a problem if you start with thin, translucent glazes of colour, because then much of the drawing will show through. This should give you the confidence to build on those glazes and in that way, using a layering process and working from light to dark, gradually develop the character and impact you have in mind for the painting.

Work in progress

Breaking Light (page 124) is typical of the way that I normally work. First, I prepare the board with the sort of surface texture that I think will be appropriate for the subject matter (see page 90). When this is dry and ready, I then draw in pencil to indicate the main parts of the composition. In this painting, the particular shapes of the bridge and buildings on the banks of the Thames needed to be quite accurate and so in those areas the drawing was more refined.

Next I work on the underpainting. As in *Breaking Light,* I often start with glazes, in this case using mostly a neutral brown colour that I thought would suit the buildings and reflect in the water below. And I also begin to consider the tonal values, here adding a darker colour in the central areas to establish the right tonal balance relative to the subject matter. Interestingly, the outline of the buildings was defined not by painting the

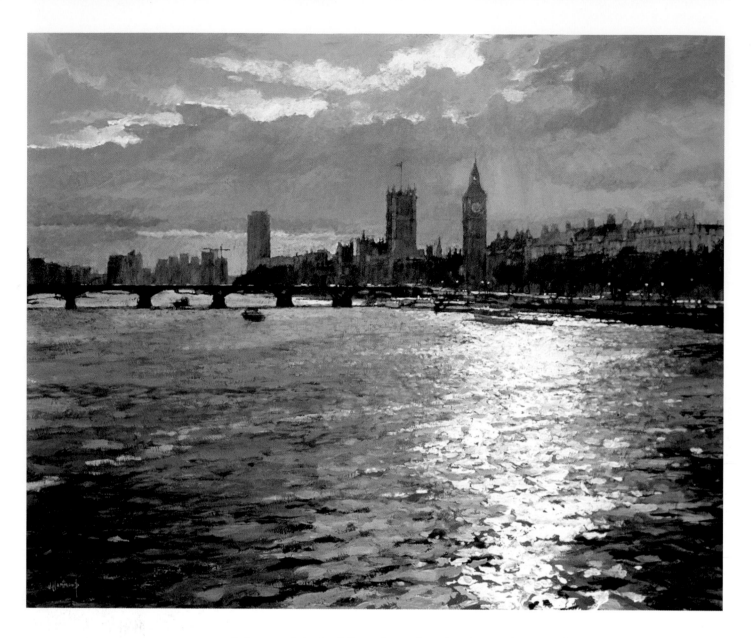

56 x 70 cm (22 x 27½ in)
This painting typifies my
preferred approach, using
sequential layers of colour
and texture to refine
the work gradually and
capture a specific sense
of time and place.

actual shapes of the buildings themselves, but by working on the 'negative' areas of the sky behind. The sky was initially loosely blocked in with a violet/blue colour.

I used a similar technique, working with the background colour, to shape the bridge and then, with fairly broad brushstrokes, I added the foreground area. At the same time, I started to develop the strong contrast between the reflected light and the rest of the water surface. Next, I returned to the central line of buildings, still partly defined by the pencil drawing showing through from the underpainting, and began to examine and define the tonal contrasts there. You can see that the sense of form and identity of these buildings essentially depends on a sequence of tonal changes.

From there on it was a matter of gradually refining the whole painting, mainly working with sequential thin layers of colour and intensifying some of the colour and tonal contrasts. Then, finally, I come to the real fun part, where I add sparkles of light and other details. In *Breaking Light*, I added touches of white, lemon and lavender to the band of light reflected in the water, ensuring that this balanced with the light in the clouds above.

Finishing touches

I prefer to work on one painting at a time, taking it to a point where I think it is finished, before moving on to another idea. Normally I start in my studio quite early in the morning and I aim to paint a large section of the picture in a single session. When it is finished, the painting is turned to the wall and left for two or three weeks. Then I put it back on the easel and reassess it. Looking at it afresh, it is usually very obvious if there is anything more to do. Sometimes I think a painting will benefit from a few more highlights or touches of colour here and there, or I may decide to apply a glaze to lift or subdue a certain area.

Morning Flight
61 x 80 cm (24 x 31½ in)
Adding those final touches –
in this case the birds – is fun
to do, but nevertheless an
equally critical step in
achieving a successful
finished result.

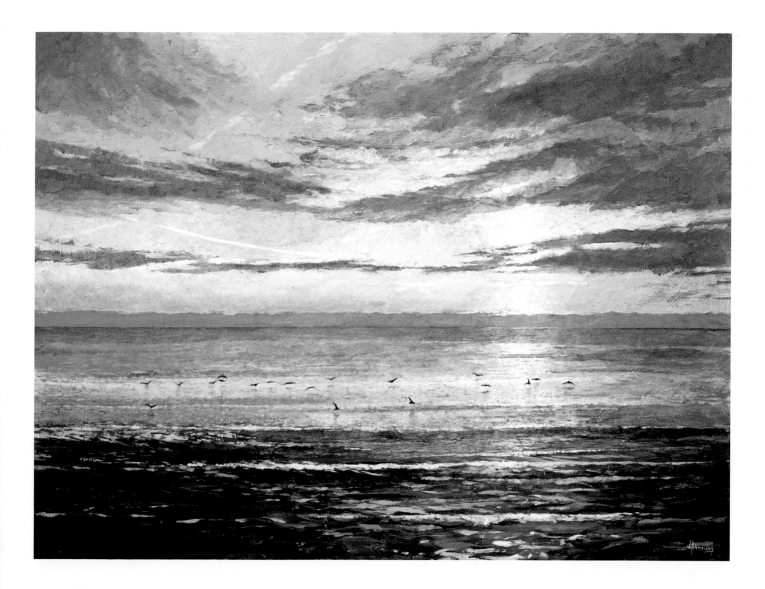

PICTURE PROFILE

By the Field's Edge

The impact of this painting is partly defined by the nature of the subject matter itself – the calm, relaxing and slightly nostalgic quality of this pastoral scene – and partly determined by the palette of colours and the tonal approach used. The main challenge, I thought, was in expressing the strong sense of depth, from the foreground grasses and cow parsley through to the background trees. To achieve that feeling of distance, I used a combination of tonal changes and paint-handling effects. The foreground colours are more intense, the brushmarks bolder, and the paint is applied in a more textural way.

Another key point that this painting demonstrates is the use of different areas of focus throughout the composition. The centre of interest is actually the group of cows in the middle distance. However, the viewer is enticed into the painting by the more detailed patch of cow parsley on the left of the foreground area, and from this two curving lines lead the eye back to the cows and the texture and tonal interest of the large tree. In *By the Field's Edge*, as in all paintings, creating impact principally relies on what I would term 'the language of paint'. The brushmarks have to read in a particular way, so that they convey the right meaning. And that is the real skill of painting. Moreover, in my opinion, there is no better medium for expressing ideas in a truly personal way than acrylics.

By the Field's Edge
71 x 61 cm (28 x 24 in)

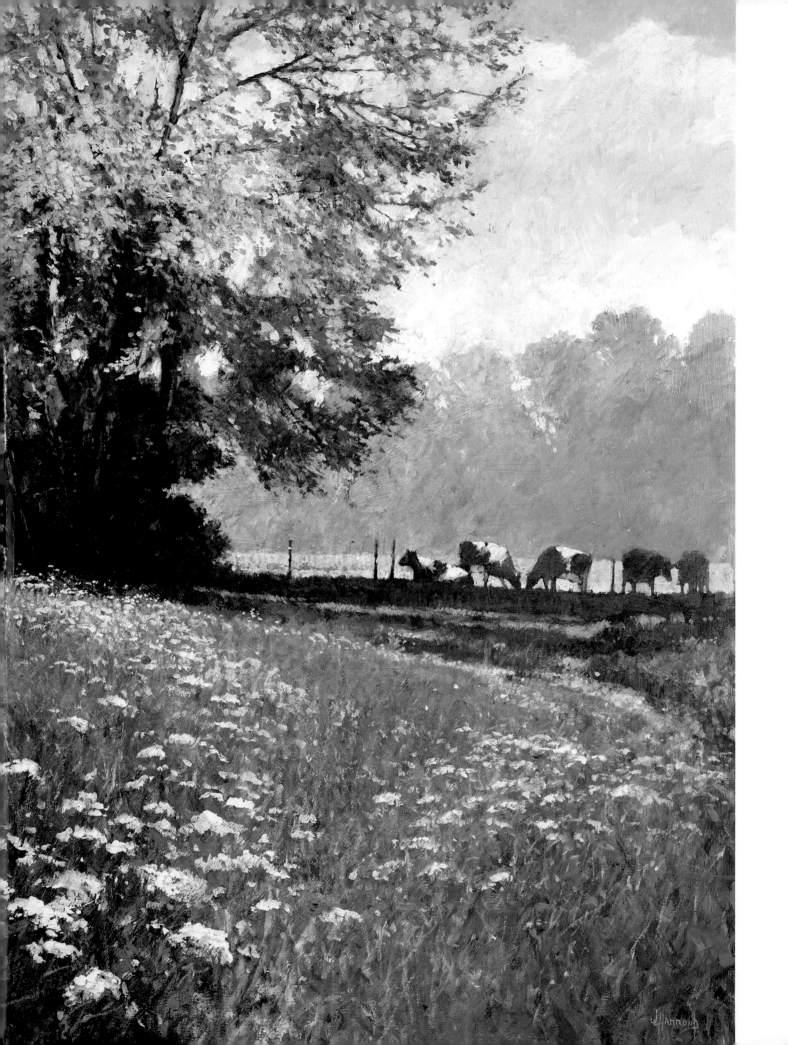

Index